A HISTORY OF
VAMPIRES
— IN —
NEW ENGLAND

THOMAS D'AGOSTINO

PHOTOGRAPHY BY ARLENE NICHOLSON

Haunted America

Published by Haunted America
A Division of The History Press
Charleston, SC 29403
www.historypress.net

Copyright © 2010 by Thomas D'Agostino
All rights reserved

First published 2010
Second printing 2013

Manufactured in the United States

ISBN 978.1.59629.998.6

Library of Congress Cataloging-in-Publication Data

D'Agostino, Thomas, 1960-
A history of vampires in New England / Thomas D'Agostino ; photography by Arlene
Nicholson.
p. cm.
Includes bibliographical references and index.
ISBN 978-1-59629-998-6
1. Vampires--New England--History. 2. New England--History. I. Title.
GR830.V3D47 2010
398'.45--dc22
2010032462

To my wife, Arlene, who has always believed in me and is always up for a good adventure into the paranormal.

CONTENTS

Acknowledgements 7

Introduction 9

A Brief History of Tuberculosis 13

Life, Death and Superstition in Early New England 15

Vampires in New England 23

1784: Willington, Connecticut 39

1793: Dummerston, Vermont 45

1793: Manchester, Vermont 49

1796: Cumberland, Rhode Island 51

1799: Exeter, Rhode Island 55

Circa Late 1700 to Early 1800: Griswold, Connecticut 63

1807: Plymouth, Massachusetts 67

1810: Barnstead, New Hampshire 71

1817: Woodstock, Vermont 73

1827: Foster, Rhode Island 77

1830: Woodstock, Vermont 83

1841: Smithfield, Rhode Island 85

1847–1862: Saco, Maine 89

1854: Jewett City, Connecticut 93

1874: South Kingstown/Exeter, Rhode Island 99

CONTENTS

1870s: West Stafford, Connecticut 105

1889: West Greenwich, Rhode Island 107

1892: Exeter, Rhode Island 111

Tuberculosis in the Twentieth Century 125

Other Strange Exorcisms and Interesting Legends 127

Bibliography 137

Index 141

About the Author 143

ACKNOWLEDGEMENTS

First and foremost, I would like to thank Dr. Michael E. Bell for his incredible research and unending pursuit of the New England vampire. His book, *Food for the Dead*, has been an immeasurable resource, and his aid and assistance in this book have been equally important. I would also like to thank Christopher Martin, of www.quahog.org, who was instrumental in finding some rare articles and information for this writing, and Mary Deveau, of the Griswold Historical Society, who helped me with the Connecticut vampires. Thanks also go to Mandy Pincins; Justin Badorek; Ron Kolek (the modern-day "Van Helsing"); Ron Kolek Jr.; Joseph Citro; Dr. Nicholas Bellantoni; Jeff Belanger; author Christopher Rondina, who has spent years researching and writing about vampires; Carol Lyons of the Foster, Rhode Island Town Hall; noted Rhode Island historian Edna Kent; the Greenville Public Library; the Putnam Public Library; the Tyler Free Library in Foster, Rhode Island; the Providence Public Library; the Town of Dummerston, Vermont; Lori and John DaSilva; the Otis Free Library; the *Providence Journal Bulletin*; Anthony Dunne of WGBY; Rhode Island PBS; Joe Nickell; and everyone who wished to remain anonymous but were instrumental in the creation of this book.

Introduction

Of all the creatures in history, the vampire is perhaps the most enigmatic. Scores of books, movies and television series have bestowed upon this being many guises, from hideous and grotesque to charming and gentle—and sometimes even comical. The New England vampire was, in its own right, a whole different character than what we have seen in film or print. In the events that took place during the eighteenth and nineteenth centuries, the vampire of New England took on a role as a spiritual being rising from the grave to feed on the living.

The disease then known as consumption and now known as tuberculosis was sending family members one by one to the tomb. There was no cure at the time, and where medicine failed, folklore took over. At the time, the word "vampire" never crossed the lips of these fearful citizens, at least not loud enough for anyone to hear. The living were convinced that the spirit of one of their recently deceased was rising from the grave to feed on family members, thus spreading the dreaded disease from one person to the next. Most New England families were inclined to believe that the spirit fed only on family members, afraid of being discovered. In some cases, families lost up to five members within the span of a year. Other cases show that consumption claimed the mortal frames of loved ones over a period of several years or perhaps decades. One must figure, however, that if a family lost three or four members in the course of several years, it would have been devastating.

Scores of families began exhuming their loved ones in search of the devil's concubine among them that was mercilessly sapping the life from them. They looked for certain telltale signs that would convince them that a vampire was

at work. Among those signs was a bloated body, signifying that the spirit had recently fed. Blood around the mouth was also a mark of a recent nightly visit. Other indications were hair and fingernails that appeared as if they had grown, pale flesh, a body in little or no state of decay and perhaps even movement within the coffin. The heart was usually removed from the corpse and cut open. If fresh blood dribbled from the organ, it was known beyond the shadow of a doubt that the "vampire" had been found.

The most common practice of New England exorcisms for vampirism consisted of removing the heart, liver and lungs, burning them and feeding the ashes to the inflicted, mixed with some sort of medicine or water, as a remedy for their illness. Sometimes other forms of exorcism were instituted, as you will soon read.

Today, it sounds quite unreasonable for such rituals to take place, but we must keep in mind the fact that families were literally being wiped out by the dreaded consumption. In some cases, neighbors feared that the "vampire" would soon prey on them when the last of its kin was gone.

As you read these pages, you will find that the New England vampire was also quite an enigma. Many of the accounts are well documented and available for the interested to peruse. Others are extremely vague, and most of the graves are no longer in existence or are marked with fieldstones in a family plot, making it difficult to pinpoint who is buried where. Our research and investigations of these burial yards, based on what little we had to go on, proves that many times family members succumbed to consumption in rapid succession. Often, the family was forced to make hand-hewn stones out of fieldstone to serve as markers until more proper stones could be procured, sometimes years later, if at all. Money was also an issue when a proper stone was to be made, as the devastation of the disease left most families financially wrought, especially when the patriarch of the clan, who may have run a skilled business, passed unexpectedly, leaving a widow to tend to the farm or business.

When Obidiah Higginbotham of Pomfret, Connecticut, died in 1803, his wife, Dorcas, had to sell what she could to pay their debts, including land and possessions. Obidiah ran a small business, the Higginbotham Spinning Wheel Company, on the Nightingale Brook that ran behind the home. The family continued to make the wheels, as Darius Higginbotham had learned the trade. Men taught their young the tricks of their trade early so that they might someday inherit the family profession or become self-sufficient.

In rural New England, fieldstone markers were quite common in early burials. Wood was also used. Some markers bear a roughly carved

inscription, while others are plain slates marking the final vestiges of one's tenure on this earth.

Contained within these pages are various cases of the history of the New England vampire as best we know it. These are by far not the only instances of exorcism for vampirism. Scholars have concluded that many more exorcisms went on undocumented. This is a chapter in New England history that has made for many scary tales, best told when the moon is full and the coyotes howl in the distance.

Note: In regard to cemeteries, some are on private property, so please do not trespass without proper permission from the owners. Those burial grounds that are public should always be respected, and all rules and regulations pertaining to them should be followed.

A BRIEF HISTORY OF TUBERCULOSIS

Tuberculosis, or tubercles bacillus, has been a plague on mankind for millennia. It is estimated that the disease has existed for about fifteen to twenty thousand years. Archaeologists and anthropologists have found that the disease was present during the Neolithic period based on bones found in Heidelberg, Germany. During this period, also called the new Stone Age, humans began evolving from hunters and gatherers into settled farmers. The exact dates of the period vary from culture to culture, but it is generally accepted that it came about around 10,000 BCE.

As opposed to the Paleolithic period, during the Stone Age humans began to use more complex tools and learned the arts of weaving and pottery making. They began to settle into villages and built more permanent structures. Farming communities were established, and the domestication of animals created the necessity to possess and cultivate tracts of land. Forms of money began to emerge, and so did the need for more multifaceted governing bodies. This was a major transition in the establishment of what would become towns and cities.

It was also during this settling and farming period that tuberculosis was reportedly introduced to humans through *Mycobacterium bovis*, found in animals during the first eras of domestication. Dr. Robert Koch would later prove that the bacilli found in humans differed from that found in bovines. In fact, retired Rhode Island veterinarian Dr. Peter Campellone states that although it may be possible for bovine TB to be passed on to humans, he has never known of any cases:

> *To prevent any sort of possibility, all lactating dairy cows are regularly tested for TB. If tested positive, it is not necessarily an indication of TB*

positive but could be a false positive. The herd is then quarantined and tested again after ninety days. Sometimes whole herds can be classified as TB positive if enough of them test positive for the disease.

The USDA testing procedures have to be strict and thorough to ensure the safety of both herds and humans.

Tuberculosis mostly attacks the lungs but has been known to settle in other parts of the body as well. Symptoms include a chronic cough (in some cases violent enough to cause damage to the ribs), spitting blood, night sweats, fever and extreme weight loss, making one look pallid and graven as one's eyes recede into their sockets and one's frame becomes pale and gaunt. The afflicted could also suffer from delirium before succumbing to the dreaded disease. This explains why many of the children who later died from the disease confessed to being visited by one of their siblings in the dark hours of the night.

The Old Testament refers to a consumptive malady that affected the Jewish people during their tenure in Egypt, a region that is known for its high incidence of cases. Dr. Campellone also points to the disease being found in mummies.

Historically speaking, tuberculosis has gone under the guise of many names: phthisis, Pott's disease, scrofula, the white plague and, of course, consumption. Early scholars were at odds over the contraction and treatment of the disease. Hippocrates, in describing the symptoms of what he called phthisis, concluded that whole families being infected meant that the illness was hereditary and not contagious. Aristotle was in sharp disagreement, stating that phthisis was, indeed, highly contagious and not hereditary.

Marcus Vitruvius Pollio (ca. 80–70 BC, died after 15 BC), a Roman writer, architect and engineer, made a curious discovery that he felt was pertinent to those afflicted with the disease. He noted that colds, pleurisy and phthisis ran rampant in regions where the wind blew from the north to the northwest. He went as far as to request that walls be built in these areas to shelter the population from these afflicting winds. One curious point of interest is that in New England, the winds are known to blow from the north. That is why many early homes of the region were constructed with the strong side of the structure facing toward the north. The low-hanging roofs and minimal amount of windows protected the inhabitants from these nor'easters. The cold, damp, northerly winds are still blamed for bringing colds and flu to a majority of the New England populace each season.

In 1720, Benjamin Marten concluded that a microscopic organism called animacula, which could thrive and multiply in a host's body, was the cause of consumption. His theory was widely rejected. It would be 162 years before Dr. Robert Koch would prove this theory to be fact.

LIFE, DEATH AND SUPERSTITION IN EARLY NEW ENGLAND

In early New England, death was a common, horrible reality. There were many diseases to match the perils New Englanders faced, contributing to high mortality rates, especially among children. Families had many children knowing that the chances of them dying at a young age were significant. Famous Puritan minister Cotton Mather suffered the loss of eight of his fifteen children before they reached the age of two.

Bearing numerous children was a life-threatening ordeal for women, who were at high risk of dying from complications during childbirth. It was common for a woman to give birth to children in rapid succession until she could no longer have any more. Women were often weakened over time, and if they did not die from disease, childbirth or complications of having multiple children, they would be fortunate to see grandchildren. Families of higher means could hire a midwife and doctor to assist in births. After childbirth, the wealthy mother would spend up to three or four weeks recovering from the ordeal, being pampered and cared for in every way necessary. In poorer, more self-sufficient homes, it was common for the woman to be back on her feet and tending to the daily chores within a few days. In healthy environments, death during childbirth was as high as one in eight woman, and the mortality rate for children dying by the age of five was one in ten. In rural New England, where doctors were scarce, one out of four children was not expected to live past five years of age.

Life expectancy in the eighteenth and nineteenth centuries varied from region to region and was in direct relation to social status. Wealthy women rarely tended to their own chores and therefore were subject to an early death

due to lack of physical exercise that created health problems later in life. For instance, even in the Gilded Age, Newport, Rhode Island's elite would be waited on hand and foot. The women looked forward to their afternoon promenade down Bellevue Avenue, where they would wave to one another from their carriages. It was about the most exercise many of them had to endure. Farmers were known to live much longer due to the rigorous daily tasks of tending to their homesteads. If disease did not take them, then they were sure to live long, healthy lives. Even the women of a farming or self-sufficient household had a longer life expectancy due to the many activities they faced each day. A majority of the gravestones Arlene and I have studied in the rural areas of New England show that the self-sufficient families either died very young of disease (for lack of proper medical facilities) or lived to be very old.

Millworkers were subject to chronic illnesses and early deaths from breathing chemicals and other toxins given off into the stuffy atmospheres of the buildings, as well as the many dangers the various machines posed. All too often, workers were either maimed or killed by the apparatus in their workplaces. Harsh working conditions, unfair wages, poor health environments, long work hours and dangerous conditions made for a tough life in the mills. It is no wonder that some scholars blame the advent of the Industrial Revolution for the widespread consumption epidemic.

As we go from the cities to the rural areas, we see a different trend. In the book *Goodwives* by Laurel Thatcher Ulrich, the author writes that mothers, fathers and even the older siblings in the more rural areas during the eighteenth and nineteenth centuries did not have time to spend caring for or chasing after their children as they do in modern society. A woman's responsibility in her household was broad, and there were many roles for a proper wife to fulfill. While her husband might be tending to the crops or animals, chopping and splitting wood, hunting game or building some sort of structure, she and the younger children would help with such chores or work on food preparation and preservation, spinning, weaving or sewing. Then there was the time spent teaching the younger family members these talents, an investment that would make the children more valuable spouses or help them grow to be more self-sufficient. Often, there was not enough light in the day to fulfill these tasks, never mind time to sit and play with the toddler of the clan. Even the older siblings were usually busy helping with the routines for daily survival. Such time-consuming tasks left curious toddlers alone to wander away from less watchful eyes. All too often, a small child would disappear into a nearby stream, pond or well or lean too far over

a kettle full of water; sometimes he would not be discovered for hours. If the kettle water was boiling, then tragedy, of course, was inescapable.

Some parents dealt with the inevitable fact of child death by turning a hard cheek when it came to emotional attachment. It was difficult for many parents to become attached to an infant knowing full well that the child might not live more than a few years for a number of reasons. This also led to lack of proper nurturing to help the child develop a distinct personality within the household. It was not uncommon for toddlers to be referred to as "it" by parents and older siblings. It was also common for families to name several of their children by the same name after another had died. This act ensured that a certain family name would live on to be passed down to the next generation, but at the same time it also perpetuated the indifference parents had toward establishing separate identities for each child. The names, however, became a link to family history. Should one survive to raise his own children, he could continue the seemingly all-important family name. In searching through historical cemeteries, Arlene and I found several graves bearing the same name; some, judging by the dates, were passed down through generations, while others were those of infants who died and the name was then passed on to another member of the family in hopes someone would live long enough to perpetuate that title.

Other threats, such as Indian attacks and wild beasts, also lingered in the minds of New Englanders during this time. Diseases were too many to count, and the New England families knew well that death lurked around every corner. It is little wonder that the preternatural would also become a fear for these people. Customs and superstitions began to link themselves together, some carried from the Old World and others born in the new one. If a black cat crossed one's path, it meant ill fortune in Europe, but I once read that this was not the case in North America. In fact, it was reported to be the exact opposite—if a white cat strolled across one's lane of travel, it could be most unsettling. Why a white cat? Was this concocted after our independence from Great Britain to separate our culture from theirs? Did a white cat really cause some calamity in America once, or could it be that white cats were much harder to come across, thus securing a more favorable and unlikely chance of stumbling upon such an ill omen in the New World?

Customs we would think ludicrous today were genuinely feared as superstition and were heeded by early New Englanders. Many were even carried over to modern times by some of the rural folks still living in the bucolic farming communities of the region. Some common superstitions included opening all the doors and windows after a death so the soul of the

departed could easily find its way to the next world or not standing by the foot of the bed of a dying person so as not to obstruct the departing spirit. Some believed that the spirit of the deceased could become trapped inside a mirror; therefore, it was the job of the oldest living relative in the house to turn the mirrors toward the wall or cover them until the body was taken to the burial ground. Some folks believed that if they saw their reflection in the mirror before this was done, they would die within six months. The deceased was always taken out of the house feet first for fear that his spirit might gaze back through the threshold and glimpse a living soul. This would cause whoever was glimpsed to soon follow the deceased to the grave. It was also customary to cover everything in the house with white linen, especially the mirrors and pictures. In rural areas, beehives would be turned, and the oldest child of the family would tell the bees the sad news. It was believed that if this act went ignored, the bees would attack a member of the deceased's family. Another strange ritual was the act of allowing a relative to inhale the dying breath of the deceased.

Many things we would today consider vile or grotesque were accepted as common custom or practice in the eighteenth and nineteenth centuries. Painting the portrait of a relative or loved one after he or she died was a common practice before the advent of the camera and even after its invention. Having a family photograph taken around the casket of the deceased was also customary in some cultures and survives to this day. Surely, exhuming family members in search of a spectral bloodsucker seems outlandish now, but it was a harsh part of the reality these New England families once faced. Some farmers believed that they must tend to their crops or plant only while the moon was waxing; if they did not, they would meet a horrible fate or their crops would fail. Some people continue to adhere to these antiquated beliefs, which seem to still grip the northwestern portion of Rhode Island's rural towns. This micro-superstition ranks among countless little regional fallacies that areas adopted to rationalize fortunes and misfortunes. On the other hand, the belief that vampires were the cause of consumption can be termed a macro-superstition because it settled within the pith of a large region—namely, New England.

Micro- and macro-superstitions intertwine to create an immeasurable number of combined ideas that the New England people adopted as common practice. There is an old legend that has been related in front of many campfires and woodstoves in country stores and is also mentioned in Michael Bell's *Food for the Dead*. It says that if a gravestone is tilted, it is an indication that a demon or devil has escaped or risen from the grave. The

tales of New England legends and folklore are vast and interesting. Their origins are in many cultures that slowly blended into the beliefs and yarns that have made this region so charming and peculiar. It is amusing to see how many have survived to this day in the rural areas, from planting and harvest predictions to old-time medicinal remedies still tried—and yes, true.

In understanding the thought process of eighteenth- and nineteenth-century families affected by consumption, we must, for a moment, travel back in time and look at a few aspects of how they coped with the fragility of their mortal tenure upon this earth. The notion of death was offset by their extreme faith in religion and the afterlife. They held comfort in the fact that death was but a temporary separation of loved ones. The early inscriptions of cold, straightforward epitaphs were replaced with warmer, subtler writings in order to comfort the living, reminding them that death, although imminent, was not the eternal end.

Puritan funerals were treated as festivals, and liquor was always served. In fact, funerals were regarded as important social events. Children were required to attend at an early age in order to become accustomed to the ceremony. It was customary in many parts of New England for the family to send a pair of gloves as an invitation to the funeral of a loved one. In some cases, gold rings with death heads, winged skulls and other engravings also found on early tombstones were handed out as mementos at funerals. These practices survived past Puritan times well into the Victorian era.

The cost of liquor served at funerals could easily outweigh the coffin and burial expenses. Even the children sometimes imbibed a libation or two. The book *Social Life in Old New England* by Mary Caroline Crawford tells that Judge Sewall wrote of how his children served as pallbearers during a funeral and afterward were allowed to drink in the same manner as the adults. Another instance tells of children who acted as pallbearers in the funeral of another child and were given a tumbler of gin, water and sugar each to quaff. During many funeral processions, bottles circulated freely and were enjoyed by bearers, who took turns carrying the coffin—and the liquor—to the burying yard.

Painting a quick picture of life in New England helps one to understand why people felt the way they did. It is important to note that all of the documented vampire cases in New England take place in rural, remote areas where certain education, superstition and customs were handed down from generation to generation. In many cases, doctors and proper medicine were few and far between, and some superstitions, being much older than known medicines at the time, were certainly known to the people in one form or

another. In Monson Center, New Hampshire, Dr. John Brown was the only medical physician the town ever had. He lived there from 1750 to 1766 before removing to Plymouth, New Hampshire. According to accounts, Thomas Benton, a bright and precocious young man, was sent to medical school with proceeds from the townspeople on the premise that he would return and become the official, and only, physician of Benton, New Hampshire.

When tuberculosis actually melded its way into superstition is a matter of conjecture that also varies from culture to culture. In medieval Hungary, it was thought that the illness was caused by a doglike demon eating away at the lungs, and when the victim coughed, it was the demon barking. The disease, causing its victims to become gaunt and pale, also gave rise to many other superstitions. Strange remedies were instituted for the disease. One English remedy was to swallow live baby frogs before breakfast. Another was to have the afflicted person sleep where he would be exposed to the breath of cattle. Some sufferers were made to drink broths made by stewing the body of a dead cat or rooster. A cure for dropsy was to drink toad ashes every morning for three days while the moon was waxing. This was known to be a surefire cure for the ailment.

Such barbaric and grotesque remedies have their place in the origins of what led New Englanders to create the cure they thought was the most effective. An interesting New England cure for a sore throat or cough was to wear a sprig of garlic around one's neck. This seems very much in conjunction with repelling a vampire and the tradition of being bitten on the neck by one. Is it coincidence, or was there more to this cure than is actually mentioned? Tea made with coltsfoot and flaxseed sweetened with honey was deemed to be a powerful prophylactic for consumption. Hyssop was thought to be a powerful medicine against colds and lung disorders as well. These remedies were obviously not always effective, and in the event of their failure, there had to be a reason far beyond the natural thought. The idea of vampirism, as we now know it, did not just pop into the minds of New England families. There had to be some preconceived idea and knowledge of historic value brought from their lands of origin that amalgamated in New England and made people believe they were under the influence of some spectral, disease-spreading demon.

Antoine Augustin Calmet, a French Benedictine theologian and scholar, produced many writings on religion. One treatise in particular, written in 1746, focused on the belief in vampires. In this very thorough and well-thought-out piece of literature, Calmet actually supports the possible existence of the bloodsucking creatures, citing several cultures and countries

and detailing how one might be labeled as a vampire. Vampire scares in Europe were all too real throughout history. Countries such as Prussia, Austria and Serbia had documented cases of vampire epidemics during the first half of the eighteenth century.

In 1725, a Serbian peasant named Peter Plogojowitz died at sixty-two years of age. When nine locals died in rapid succession, they feared the work of a vampire. Victims claimed they were visited by Plogojowitz in the dark hours of the night, and he sucked the life from them. Even Plogojowitz's wife and son were subject to his nightly visitations. The corpse of Plogojowitz returned to his home and demanded sustenance from his son. When the younger refused, he was found dead from a massive loss of blood. Authorities were called in to end the terror. The body of Plogojowitz was exhumed, and when examined, signs of vampirism were present: the hair and nails appeared to have grown, and there were signs of blood in the mouth. The villagers drove a stake through Plogojowitz's heart, and fresh blood spurted from the corpse. They then burned the body.

Arnold Paole, another Serbian citizen, claimed he had been attacked by a vampire years before. In 1726, while out in his field, he suddenly died. After that, his neighbors began taking ill and dropping off one by one. It was concluded that Paole was now a vampire feeding on their blood.

These cases reached the New World through immigration and probably held some weight in people's minds. A certain writing that stands out almost puts the final nail in the coffin, so to speak, of how New Englanders linked consumption to what we now call vampires. This work is by Francois-Marie Arouet (November 21, 1694–May 30, 1777), a French philosopher and author who wrote under the pen name of Voltaire. Voltaire penned many famous quotes that still reverberate through oral tradition and prose. He also wrote a bit on vampires.

Voltaire's literature states that the vampire was a corpse that sucked the blood from the living, extracting it from the neck or the stomach. The victims, over a short period of time, grew pale and ashen in complexion while becoming weak and gaunt in appearance, until they finally contracted consumption from their weakness and wasted away. The corpse, on the other hand, flourished in the grave, remaining fresh, preserved and nourished from the juice of life it had streamed from the living. Voltaire's perception that vampire victims would contract consumption as a byproduct of their affliction is a most compelling statement. Somehow, when his cache of quotes sailed across the Atlantic with those immigrating to the new world, this one narrative, like a parasite, may have been hidden among them,

waiting for someone to unleash its dogma upon the settlers. In writing, and in reality, they had taken with them from the Old World a vampire, or some sort of spectral creature of the night, which became the sole culprit for the contraction of the horrible wasting disease.

When the *Providence Journal* printed an article on vampires in Rhode Island on March 21, 1892, the first few paragraphs caught my attention, drawing me to read more, but the comments in quotes near the beginning—"I always heard it was so," and especially, "My father and grandfather always said so"—led me to wonder how far back the belief in spectral night stalkers and family ghouls actually stems. It was probably passed down through generations by word of mouth.

My grandparents were born around the turn of the twentieth century, which means their parents and grandparents lived during the nineteenth century. Here we are in the twenty-first century, and my parents—even my brothers and sisters, along with myself—still hold fast to much of what my grandparents taught us. Their influence on cooking, holidays and possessions (passed down through the generations) while we were growing up still make for warm family solidarity and strength. We continue to use my grandmother's favorite sayings from time to time, and of course, we all have some of her possessions around the house. This goes to show how far back customs and traditions can be traced. Think about your family roots for a moment and about how many things you still hold on to that came from your parents or grandparents. Chances are, those customs, traditions, sayings and habits come from a long line of ancestry. It's not hard to understand how superstitions, especially during a time when diseases like consumption were devastating families, would also become part of the mix.

So many beliefs that were once common among our ancestors were quickly swept under the rug at the turn of the twentieth century for fear of ridicule. Perhaps even within your family history lies an undocumented incident that was all but forgotten with the advent of modern medicine and education. Was there once a vampire in your family? You never know.

Vampires in New England

Folklore has many roads. With diverse cultures mingling and migrating across this great country, it is no wonder that the legends and superstitions we have come to adhere to have become a sundry of relics passed down from generation to generation.

We all know that black cats were regarded as witch's familiars throughout history, but modern intelligence and reasoning has assuredly put that fear to rest. Folklore is deeply rooted in every society and often takes a front seat to reason. When folklore works in the place of reason and intelligence, it can become the new medicine of the day. That is what appears to have occurred in New England when a disease called consumption, now known as tuberculosis, ran rampant across the region. The medical doctors of the eighteenth and early nineteenth centuries had no cure or effective treatment for the disease. There was no pill or shot to eradicate the deadly infliction. Connecticut state archaeologist Dr. Nicholas Bellantoni informed me that consumption was the number one killer of people before the Civil War. With nowhere else to turn, it became a major health issue, and people were desperate for a cure. Many did not realize at the time that coughing on food at the table or sleeping several to a bed was perpetuating the disease. They were not yet aware that the malady was, indeed, contagious. The proximity of many of these early New England families in such cramped conditions provided an ideal breeding ground for consumption.

Dr. Michael Bell put it best in the 2002 PBS documentary *Ghosts and Vampire Legends of Rhode Island* when he stated that the medical profession of the times was "grasping at straws" in regard to treatment. This most likely

gave impetus to folklore and superstition as a focal point in the treatment of the disease.

Consumption victims were gaunt, pale and often spit up blood while coughing profusely. Their wasting away gave rise to the theory that perhaps there was something more sinister at work. Perhaps it was not just a dreadful disease but also a supernatural force that continually fed on them before eventually taking them to the grave.

The New England vampire was deemed the victim of a mystical force that made him return from the dead to feed on the living. The families knew, of course, that the dead were not actually digging themselves out of the grave each night and physically attacking their prey. The concluded that the spirit of the deceased was rising from the tomb and making its way to the bedchambers of his kin, sucking the life out of them in order to nourish the physical body that lay in repose. Many of the sick complained of how the deceased family member sat on a part of their body, causing great pain and suffering. It is a stretch of the imagination in today's society, but when one considers the times and the hardships families faced fighting for survival in an untamed environment and against countless diseases, it makes sense that folklore and superstition were part of their coping methods.

Families running out of hope of eradicating consumption from their homes looked at the idea of banishing a spectral ghoul in the family as treatment and found, in some cases, that it worked. Of course, in such cases, the afflicted person most likely overcame the illness through natural means, but this was not the belief, especially when such drastic measures as exhumation and cremation of the vitals had taken place.

To answer the question of how such ideas and the subsequent "cures" spread throughout New England, we must turn to the forefront of the early forms of media. Taverns were often stage stops where travelers could tell news and stories of the places they had just left. There were also circulars that were printed and hung on the doors with the latest news of the day. Taverns were also used for town meetings, as post offices and, in some cases, for Sunday sermons. They were the television, radio and telephone of early New England. It was mandated that there be a tavern about every five miles along the roads. People traveled mostly on foot, sometimes on horseback and rarely by carriage. One can easily see why a public house every five miles would be a necessity in the harsh New England winters, when the snow piled up along the primitive roadways, making travel of any kind a dangerously arduous task.

Country stores, much like the taverns, though not as common, were also a central point for the media of the times. News took time to move from town

to town and often became embellished in its various retellings. Stories of gunslingers, war heroes, farming mishaps and successes, fishing adventures, wild Indians, ghosts and, yes, vampires circulated. These stories were told in front of warm fires; the blustery winter bite outside could hardly compete with the chill of a well-versed narrator recounting what would become legend. The fireplace and, later, the potbellied stove became a central prop in these gatherings, where the townsfolk would pass on tales of their fathers or tidbits they heard from a passing traveler. The country store was media center, post office, gathering place and a place where liquor was sold in gills to be quaffed on the premises. Home remedies and herbs were abundant in the absence of proper medical physicians, and it is certain that much gossip and rumors of home remedies for the multitude of often-fatal illnesses were passed on to many visitors at these country stores. Customs, traditions, superstitions, social exchanges and lifestyles are among the various elements that played a chief role in this strange chapter in New England's history.

To this day, gathering place customs still thrive. My parents have owned a fishing tackle store for many years, and one of the charms of the family business is the people who come in and sit for a while, telling stories of fishing, politics, people—whatever the topic of the day. It is not uncommon to see a few chairs arranged in a semicircle in front of the rear counter of the store where regulars had gathered to enjoy a tale or two.

Country stores and taverns may be scant in modern society, but the storyteller and gossiper remains prolific in small family businesses, where tradition and stories get passed down from one to another and, in some cases, become legend.

The term "vampire" is first mentioned in writings toward the end of the nineteenth century and into the beginning of the twentieth century. As far as we know, the families and friends who exhumed loved ones for signs of vampirism never mentioned that they were looking for a vampire. They were not exactly sure how to label the demon that was preying on them, but they had come to the conclusion that consumption was the catalyst that made a spirit rise from the grave in search of the blood and strength of the living. Joseph Citro states in his book, *Passing Strange*, that the word "vampire" and its definition first appeared in the *Oxford English Dictionary* in 1734. It made its way to America when the *Hartford Courant* printed the definition in 1765.

James Earl Clauson made an interesting point in his 1937 publication, *These Plantations.* As Clauson stated in the chapter "Vampirism in Rhode Island," "Rhode Island was too liberal to interfere with ladies who wanted to sell themselves to the devil and become witches but were thumbs up on

vampires." This is a very interesting statement when considering that the founding of Rhode Island came about through want of religious freedom—a very liberal, if not downright insolent, way of thinking for the Puritan times of Roger Williams. There is one interesting case, as told by Sidney Rider in his now famous *Book Notes* from February 4, 1888, in which an old woman, a Mrs. Ann Higgins, was supposedly hanged as a witch in 1655 in Rhode Island for having more "wit" than her neighbors. Rider goes on to report that the incident took place in the colony of Massachusetts, not Rhode Island, and the name was Hibbins, not Higgins. She was accused of witchcraft and acquitted before a jury but was taken before the general court and condemned there. Rider's research into the matter concludes that there was no persecution for witchcraft in Rhode Island as there was in its neighboring state of Massachusetts. He backs up his findings by citing references from both of the states' history books, maintaining that the incident was indeed part of the Massachusetts colony in 1655 but was mistakenly credited to Rhode Island.

My research also concluded that Ann Hibbins, wife of William Hibbins, an influential merchant and one-time chief magistrate, was hanged for witchcraft in the Boston Common in 1656. Although originally acquitted by a jury, the popular voice of the people forced the magistrate to take over and condemn her, because, as stated before, she was a bit outspoken and more intelligent than her neighbors. Apparently, Clauson was fairly accurate in his quote about the acceptance of "witches" in Rhode Island. If all religions were to be accepted, then surely paganism—or some form of it—had to be welcomed as well. One must also take into consideration the knowledge and intelligence that must be present in order for the various religions to coexist with tolerance within a social structure.

It seems that the Ocean State promoted liberal thought well into the next few centuries, taking exception from this doctrine only for the creature of the night. Even a state born from liberal philosophy had no room for the thought that vampires might roam its landscape freely. Puritan minister Cotton Mather referred to Rhode Island as the "sewer of New England" because of its liberal tendencies in welcoming different religions. The nineteenth century was a period in which many religions began to flourish, and even churches of different denominations sat side by side along town greens. These widespread faiths meant diverse cultures. It would seem inevitable that the commingling of these people during social events would bring about the weaving together of many traditions. In his book *Food for the Dead*, Dr. Michael Bell noted that the New England vampire cases took place outside the boundaries of Puritan influence.

Vampires in New England

In the case of the Rhode Island vampire, there seemed to be certain criteria that did not prevail within the usual signs of vampirism found throughout New England. In all other states, the vampire could be a man or woman of any age; in Rhode Island, all vampires were women between the ages of fifteen and twenty-two. This is not so strange when one considers that the female vampire exists in many countries. India has the *Raksasha*; Scotland, the *glaistig*; and Ireland, *leanan sidhe*, who takes the form of a beautiful woman no man can resist. Many poems, stories and drawings have made the *leanan sidhe* one of the most famous creatures of the night in British Isles folklore. The *Gwrach-y-rhybin* of Wales attacks individuals as they sleep, especially children. *Les dames blanches* ("white ladies") of France were also known to appear as beautiful women to their prey. They are said to stem from the lady of the oak, Druantia, queen of the druids. All of these creatures reside in cultures whose people immigrated to New England long ago. Did immigrants take their Old World superstitions with them, tucked in the back of their minds?

In the October 1992 issue of *Old Rhode Island*, Donald Boisvert wrote an article on vampires and other Rhode Island legends. In the article, he quotes former Boston College history professor Dr. Raymond T. McNally, who refers to the Ocean State as the "Transylvania of America" due to the similarities in the rural South County hamlets and those of Transylvania, where McNally, according to Boisvert, spent years researching Dracula and the history of vampirism. South County was where most of the reported cases of vampirism in New England took place. Subsequent writers have claimed that there were more exhumations in that region than what has been penned. One theory Boisvert puts forth to explain why the southern part of the state saw so much more activity than the northern areas was the fact that the *Narragansett Times*, a predominantly South County–based paper, consistently printed front-page articles on séances held in Boston. During the latter part of the nineteenth century, the Spiritualist movement was at its peak, and such beliefs as talking to the dead were both common and popular. If one could openly communicate with the other side, who could say what other ethereal or supernatural possibilities could be tapped?

There is also the fact that record keeping was not as accurate. Neither were all of the stories that were handed down as research for the subject. Reporters from the city papers rode out to these little rural hamlets in search of a story and got bits and pieces from the locals. Some knew of a legend, and others just speculated about what may have happened. Then there is the fact that two or three legends often became one through interviews with

the villagers. This is a dilemma that has kept modern researchers digging through historical records, looking to shed light on the mysteries surrounding the New England vampire. In some cases, we find that details are vague and there is not much solid fact to back them up, while others are well narrated in both pen and the spoken word. These cases remain a lasting testament to the history of the New England vampire.

The following article appeared in the *American Anthropologist* in January 1896. It was written by George Stetson and is considered by many to be one of the most important documents on the New England vampire.

The Animistic Vampire in New England
George R. Stetson
American Anthropologist *9, no. 1 (January 1896)*

The belief in the vampire and the whole family of demons has its origin in the animism, spiritism, or personification of the barbarian, who, unable to distinguish the objective from the subjective, ascribes good and evil influences and all natural phenomena to good and evil spirits.

Mr. Conway remarks of this vampire belief that "it is, perhaps, the most formidable survival of demonic superstition now existing in the world."

Under the names of vampire, were-wolf, man-wolf, night-mare, night-demon—in the Illyrian tongue oupires, *or leeches; in modern Greek* broucolaques, *and in our common tongue ghosts, each country having its own peculiar designation—the superstitious of the ancient and modern world, of Chaldea and Babylon, Persia, Egypt, and Syria, of Illyria, Poland, Turkey, Servia, Germany, England, Central Africa, New England, and the islands of the Malay and Polynesian archipelagoes, designate the spirits which leave the tomb, generally in the night, to torment the living.*

The character, purpose, and manner of the vampire manifestations depend, like its designation, upon environment and the plane of culture.

All primitive peoples have believed in the existence of good and evil spirits holding a middle place between men and gods. Calmet lays down in most explicit terms, as he was bound to do by the canons of his church, the doctrine of angels and demons as a matter of dogmatic theology.

The early Christians were possessed, or obsessed, by demons, and the so-called demoniacal possession of idiots, lunatics, and hysterical persons is still common in Japan, China, India, and Africa, and instances are noted in Western Europe, all yielding to the methods of Christian and pagan exorcists as practiced in New Testament times.

The Hebrew synonym of demon was serpent; the Greek, diabolus, a calumniator, or impure spirit. The Rabbins were divided in opinion, some believing they were entirely spiritual, others that they were corporeal, capable of generation and subject to death.

As before suggested, it was the general belief that the vampire is a spirit which leaves its dead body in the grave to visit and torment the living.

The modern Greeks are persuaded that the bodies of the excommunicated do not putrefy in their tombs, but appear in the night as in the day, and that to encounter them is dangerous.

Instances are cited by Calmet, in Christian antiquity, of excommunicated persons visibly arising from their tombs and leaving the churches when the deacon commanded the excommunicated and those who did not partake of the communion to retire. The same writer states that "it was an opinion widely circulated in Germany that certain dead ate in their tombs and devoured all they could find around them, including their own flesh, accompanied by a certain piercing shriek and a sound of munching and groaning."

A German author has thought it worth while to write a work entitled "De Masticatione mortuorum in tumulis." In many parts of England a person who is ill is said to be "wisht" or "overlooked." The superstition of the "evil eye" originated and exists in the same degree of culture; the evil eye "which kills snakes, scares wolves, hatches ostrich eggs, and breeds leprosy." The Polynesians believed that the vampires were the departed souls, which quitted the grave, and grave idols, to creep by night into the houses and devour the heart and entrails of the sleepers, who afterward died.[1]

The Karems tell of the Kephu, which devours the souls of men who die. The mintira of the Malay peninsula have their water demon, who sucks blood from men's toes and thumbs.

"The first theory of the vampire superstitions," remarks Tyler,[2] "is that the soul of the living man, often a sorcerer, leaves its proper body asleep and goes forth, perhaps in visible form of a straw or a fluff of down, slips through the keyhole, and attacks a living victim. Some say these Mauri come by night to men, sit upon their breasts, and suck their blood, while others think children alone are attacked, while to men they are nightmares.

"The second theory is that the soul of a dead man goes out from its buried body and sucks the blood of living men; the victim becomes thin, languid, bloodless, and, falling into a rapid decline, dies."

The belief in the Obi of Jamaica and the Vaudoux or Vodun of the West African coast, Jamaica and Haiti is essentially the same as that of the vampire,

and its worship and superstitions, which in Africa include child-murder, still survive in these parts, as well as in several districts among the negro population of our southern states. The negro laid under the ban of the Obi or who is vaudouxed or, in the vernacular, "hoodooed," slowly pines to death.

In New England the vampire superstition is unknown by its proper name. It is there believed that consumption is not a physical but a spiritual disease, obsession, or visitation; that as long as the body of a dead consumptive relative has blood in its heart it is proof that an occult influence steals from it for death and is at work draining the blood of the living into the heart of the dead and causing his rapid decline.

It is a common belief in primitive races of low culture that disease is caused by the revengeful spirits of man or other animals—notably among the tribes of North American Indians as well as of African negroes.

Russian superstition supposes nine sisters who plague mankind with fever. They lie chained up in caverns, and when let loose pounce upon man without pity.[3]

As in the financial and political, the psychologic world has its periods of exultation and depression, of confidence and alarm. In the eighteenth century a vampire panic beginning in Servia and Hungary spread thence into northern and western Europe, acquiring its new life and impetus from the horrors attending the prevalence of the plague and other distressing epidemics in an age of great public moral depravity and illiteracy. Calmet, a learned Benedictine monk and abbé of Sénones, seized this opportunity to write a popular treatise on the vampire, which in a short time passed through many editions. It was my good fortune not long since to find in the Boston Athenaeum library an original copy of his work. Its title page reads as follows: "Traité sur les apparitions des esprits et sur les vampires ou les revenans de Hongrie, de Moravie, etc. Par le R.P. Dom Augustine Calmet, abbé de Sénones. Nouvelle edition, revisée, corrigie, at augmentie par l'auteur, avec une lettre de Mons le Marquis Maffei, sur le magie. A Paris; Chez debure l'aine quay des Augustins à l'image S. Paul. MDCCLI. Avec approb et priv du roi."

Calmet was born in Lorraine, near Commercy, in 1672, and his chief works were a commentary and history of the Bible. He died as the abbé de Sénones, in the department of the Vosges.

This curious treatise has evidently proved a mine of wealth to all modern encyclopedists and demonologists. It impresses one as the work of a man whose mental convictions do not entirely conform to the traditions and dogmas of his church, and his style at times appears somewhat apologetic.

Calmet declares his belief to be that the vampires of Europe and the broucolaques of Greece are the excommunicated which the grave rejects. They are the dead of a longer or shorter time who leave their tombs to torment the living, sucking their blood and announcing their appearance by rattling of doors and windows. The name vampire, or d'oupires, *signifies in the Slavonic tongue a bloodsucker. He formulates the three theories then existing as to the cause of these appearances:*

First: That the persons were buried alive and naturally leave their tombs.

Second: That they are dead, but that by God's permission or particular command they return to their bodies for a time, as when they are exhumed their bodies are found entire, the blood red and fluid, and their members soft and pliable.

Third: That it is the devil who makes these apparitions appear and by their means causes all the evil done to men and animals.

In some places the spectre appears as in the flesh, walks, talks, infests villages, ill uses both men and beasts, sucks the blood of their near relations, makes them ill, and finally causes their death.

The late Monsieur de Vassimont, counselor of the chamber of the courts of Bar, was informed by public report in Monravia that it was common enough in that country to see men who had died some time before "present themselves at a party and sit down to table with persons of their acquaintance without saying a word and nodding to one of the party, the one indicated would infallibly die some days after." [4]

About 1735 on the frontier of Hungary a dead person appeared after ten years' burial and caused the death of his father. In 1730 in Turkish Servia it was believed that those who had been passive vampires during life became active after death; in Russia, that the vampire does not stop his unwelcome visits at a single member of a family, but extends his visits to the last member, which is the Rhode Island belief.

The captain of grenadiers in the Regiment of Monsieur le Baron Trenck, cited by Calmet, declares "that it is only in their family and among their own relations that the vampires delight in destroying their own species."

The inhabitants of the island of Chio do not answer unless called twice, being persuaded that the broucolaques do not call but once, and when so called the vampire disappears, and the person called dies in a few days. The classic writers from Socrates to Shakespeare and from Shakespeare to our own time have recognized the superstition.

Mr. Conway quotes from the legend of Ishtar descending to Hades to seek some beloved one. She threatens if the door is not opened—

"I will raise the dead to be devourers of the living;
Upon the living shall the dead prey." [5]

Singularly, in his discourse on modern superstitions De Quincey, to whom crude superstitions clung and who had faith in dreams as portents, does not allude to the vampire; but his contemporary, Lord Byron, in his lines on the opening of the royal tomb at Windsor, recognizes this belief in the transformation of the dead:

"Justice and death have mixed their dust in vain,
Each royal vampire wakes to life again."

William of Malmsbury says that "in England they believed that the wicked came back after death by the will of the devil," and it was not an unusual belief that those whose death had been caused in this manner, at their death pursued the same evil calling. Naturally under such an uncomfortable and inconvenient infliction some avenue of escape must, if possible, be found. It was first necessary to locate the vampire. If on opening the grave of a "suspect" the body was found to be of a rose color, the beard, hair and nails renewed, and the veins filled, the evidence of its being the abode of a vampire was conclusive. A voyager in the Levant in the seventeenth century is quoted as relating that an excommunicated person was exhumed and the body found full, healthy, and well disposed and the veins filled with the blood the vampire had taken from the living. In a certain Turkish village, of forty persons exhumed seventeen gave evidence of vampirism. In Hungary, one dead thirty years was found in a natural state. In 1727 the bodies of five religieuse were discovered in a tomb near the hospital of Quebec, that had been buried twenty years, covered with flesh and suffused with blood. [6]

The methods of relief from or disposition of the vampire's dwelling place are not numerous, but extremely sanguinary and ghastly.

In Servia a relief is found in eating of the earth of his grave and rubbing the person with his blood. This prescription was, however, valueless if after forty days the body was exhumed and all the evidences of an archivampire were not found. A more common and almost universal method of relief, especially in the Turkish provinces and in the Greek islands, was to burn the body and scatter the ashes to the winds. Some old writers are of the opinion that the souls of the dead cannot be quiet until the entire body has been consumed. Exceptions are noted in the Levant, where the body is cut in pieces and boiled in wine, and where, according to Voltaire, the heart is torn out and burned.

In Hungary and Servia, to destroy the demon it was considered necessary to exhume the body, insert in the heart and other parts of the defunct, or pierce

it through with a sharp instrument, as in the case of suicides, upon which it utters a dreadful cry, as if alive; it is then decapitated and the body burned. In New England the body is exhumed, the heart burned, and the ashes scattered. The discovery of the vampire's resting-place was itself an art.

In Hungary and in Russia they choose a boy young enough to be certain that he is innocent of any impurity, put him on the back of a horse which has never stumbled and is absolutely black, and make him ride over all the graves in the cemetery. The grave over which the horse refuses to pass is reputed to be that of a vampire.

Gilbert Stuart, the distinguished American painter, when asked by a London friend where he was born, replied: "Six miles from Pottawoone, ten miles from Poppasquash, four miles from Conanicut, and not far from the spot where the famous battle with the warlike Pequots was fought."
In plainer language, Stuart was born in the old snuff mill belonging to his father and Dr. Moffat, at the head of the Petaquamscott pond, six miles from Newport, across the bay, and about the same distance from Narragansett Pier, in the state of Rhode Island.

By some mysterious survival, occult transmission, or remarkable atavisim, this region, including within its radius the towns of Exeter, Foster, Kingstown, East Greenwich, and others, with their scattered hamlets and more pretentious villages, is distinguished by the prevalence of this remarkable superstition—a survival of the days of Sardanapalus, of Nebuchadnezzar, and of New Testament history in the closing years of what we are pleased to call the enlightened nineteenth century. It is an extraordinary instance of a barbaric superstition outcropping in and coexisting with a high general culture, of which Max Müller and others have spoken, and which is not so uncommon, if rarely so extremely aggravated, crude, and painful.

The region referred to, where agriculture is in a depressed condition and abandoned farms are numerous, is the tramping ground of the book agent, the chromo peddler, the patent-medicine man and the home of the erotic and neurotic modern novel. The social isolation away from the larger villages is as complete as a century and a half ago, when the boy Gilbert Stuart tramped the woods, fished the streams, and was developing and absorbing his artistic inspirations, while the agricultural and economic conditions are very much worse.[7] Farm houses deserted and ruinous are frequent, and the once productive lands, neglected and overgrown with scrubby oak, speak forcefully and mournfully of the migration of the youthful farmers from country to town. In short, the region furnishes an object-lesson in the decline of wealth consequent upon the prevalence of a too common heresy in the

district that land will take care of itself, or that it can be robbed from generation to generation without injury, and suggests the almost criminal neglect of the conservators of public education to give instruction to our farming youth in a more scientific and more practical agriculture. It has well been said by a banker of well-known name in an agricultural district in the midlands of England that "the depression of agriculture is a depression of brains." Naturally, in such isolated conditions the superstitions of a much lower culture have maintained their place and are likely to keep it and perpetuate it, despite the church, the public school, and the weekly newspaper. Here Cotton Mather, Justice Sewall, and the host of medical, clerical and lay believers in the uncanny superstitions of bygone centuries could still hold high carnival.

The first visit in this farming community of native-born New Englanders was made to ------, a small seashore village possessing a summer hotel and a few cottages of summer residents not far from Newport—that Mecca of wealth, fashion, and nineteenth-century culture. The ------ family is among its well-to-do and most intelligent inhabitants. One member of this family had some years since lost children by consumption, and by common report claimed to have saved those surviving by exhumation and cremation of the dead.

In the same village resides Mr. ------, an intelligent man, by trade a mason, who is a living witness of the superstition and of the efficacy of the treatment of the dead which it prescribes. He informed me that he had lost two brothers by consumption. Upon the attack of the second brother his father was advised by Mr. ------, the head of the family before mentioned, to take up the first body and burn its heart, but the brother attacked objected to the sacrilege and in consequence subsequently died. When he was attacked by the disease in his turn, ------'s advice prevailed, and the body of the brother last dead was exhumed, and "living" blood being found in the heart and in circulation, it was cremated, and the sufferer began immediately to mend and stood before me and hale, hearty, and vigorous man of fifty years. When questioned as to his understanding of the miraculous influence, he could suggest nothing and did not recognize the superstition even by name. He remembered that the doctors did not believe in its efficacy, but he and many others did. His father saw the brother's body and the arterial blood. The attitude of several other persons in regard to the practice was agnostic, either from fear of public opinion or other reasons, and their replies to my inquiries were in the same temper of mind as that of the blind man in the Gospel of Saint John (9:25), who did not dare to express his belief, but

"answered and said, Whether he was a sinner or no, I know not; one thing I know, that whereas I was blind, now I see."

At ------, a small isolated village of scattered houses in a farming population, distant fifteen or twenty miles from Newport and eight or ten from Stuart's birthplace, there have been made within fifty years a half dozen or more exhumations. The most recent was made within two years, in the family of ------. The mother and four children had already succumbed to consumption, and the child most recently deceased (within six months) was, in obedience to the superstition, exhumed and the heart burned. Dr. ------, who made the autopsy, stated that he found the body in the usual condition after an interment of that length of time. I learned that others of the family have since died, and one is now very low with the dreaded disease.

The doctor remarked that he consented to the autopsy only after the pressing solicitation of the surviving children, who were patients of his, the father first objecting, but finally, under continued pressure, yielding. Dr. ------ declares the superstition to be prevalent in all the isolated districts of southern Rhode Island, and that many instances of its survival can be found in the large centers of population. In the village now being considered known exhumations have been made in five families, and in two adjoining villages in two families. In 1875 an instance was reported in Chicago, and in a New York journal of recent date I read the following: "At Peukuhl, a small village in Prussia, a farmer died last March. Since then one of his sons has been sickly, and believing that the dead man would not rest until he had drawn to himself the nine surviving members of the family, the sickly son, armed with a spade, exhumed his father and cut off his head." It does not by any means absolutely follow that this barbarous superstition has a stronger hold in Rhode Island than in any other part of the country. Peculiar conditions have caused its manifestation and survival there, and similar ones are likely to produce it elsewhere. The singular feature is that it should appear and flourish in a native population which from its infancy has had the ordinary New England educational advantages; in a State having a larger population to the square mile than any in the Union, and in an environment of remarkable literacy and culture when compared to some other sections of the country. It is perhaps fortunate that the isolation of which this is probably the product, an isolation common in sparsely settled regions, where thought stagnates and insanity and superstition are prevalent, has produced nothing worse.

In neighboring Connecticut, within a few miles of its university town of New Haven, there are rural farming populations, fairly prosperous, of

average intelligence, and furnished with churches and schools, which have made themselves notorious by murder, suicides, and numerous instances of melancholia and insanity.

Other abundant evidence is at hand pointing to the conclusion that the vampire superstition still retains its hold in its original habitat—an illustration of the remarkable tenacity and continuity of a superstition through centuries of intellectual progress from a lower to a higher culture, and of the impotency of the latter to entirely eradicate from itself the traditional beliefs, customs, habits, observances, and impressions of the former.

It is apparent that our increased and increasing culture, our appreciation of the principles of natural, mental, and moral philosophy and knowledge of natural laws has no complete correlation in the decline of primitive and crude superstitions or increased control of the emotions or the imagination, and that to force a higher culture upon a lower, or to metamorphose or to perfectly control its emotional nature through education of the intellect, is equally impossible. The two cultures may, however, coexist, intermingling and in a limited degree absorbing from and retroacting favorably or unfavorably upon each other—trifling aberrations in the inexorable law which binds each to its own place.

The most enlightened and philosophic have, either apparent or secreted in their innermost consciousness, superstitious weaknesses—negative, involuntary, more or less barbaric, and under greater or lesser control in correspondence with their education, their present environment, and the degree of their development—in the control of the imagination and emotions. These in various degrees predominate over the understanding where reason is silent or its authority weakens.

Sónya Kovalévsky (1850–1890), one of the most brilliant mathematicians of the century, who obtained the Prix-Bordin from the French academy, "the greatest scientific honor ever gained by a woman," "whose love for mathematical and psychological problems amounted to a passion," and whose intellect would accept no proposition incapable of a mathematical demonstration, all her life maintained a firm belief in apparitions and in dreams as portents. She was so influenced by disagreeable dreams and the apparition of a demon as to be for some time thereafter obviously depressed and low-spirited.

A well-known and highly cultured American mathematician recently said to me that his servant had seven years ago nailed a horseshoe over a house door, and that he had never had the courage to remove it.

Vampires in New England

There is in the Chemnitzer-Rocken Philosophie, cited by Grimm, a register of eleven or twelve hundred crude superstitions surviving in highly educated Germany. Buckle declared that "superstition was the curse of Scotland," and in this regard neither Germany nor Scotland are singular.

Of the origin of this superstition in Rhode Island or in other parts of the United States we are ignorant; it is in all probability an exotic like ourselves, originating in the mythographic period of the Aryan and Semitic peoples, although legends and superstitions of a somewhat similar character may be found among the American Indians.

The Ojibwas have, it is said, a legend of a ghostly man-eater. Mr. Mooney, in a personal note, says he has not met with any close parallel of the vampire myth among the tribes with which he is familiar. The Cherokees have, however, something analogous. There are in that tribe quite a number of old witches and wizards who thrive and fatten upon the livers of murdered victims. When some one is dangerously sick these witches gather invisibly about his bedside and torment him, even lifting him up and dashing him down again upon the ground until life is extinct. After he is buried they dig up his body and take out the liver to feast upon. They thus lengthen their own lives by as many days as they have taken from his. In this way they get to be very aged, which renders them objects of suspicion. It is not, therefore, well to grow old among the Cherokees. If discovered and recognized during the feast, when they are again visible, they die within seven days.

I have personal experience of a case in which a reputed medicine-man was left to die alone because his friends were afraid to come into the house on account of the presence of invisible witches.

Jacob Grimm[8] defines superstition as a persistence of individual men in views which the common sense or culture of the majority has caused them to abandon, a definition which, while within its limits sufficiently accurate, does not recognize or take account of the subtile, universal, ineradicable fear of or reverence for the supernatural, the mysterious, and unknown.

De Quincey has more comprehensively remarked that "superstition or sympathy with the invisible is the great test of man's nature as an earthly combining with a celestial. In superstition is the possibility of religion, and though superstition is often injurious, degrading and demoralizing, it is so, not as a form of corruption or degradation, but as a form of non-development."

In reviewing these cases of psychologic pre-Raphaelitism they seem, from an economic point of view, to form one of the strongest as well as the

weirdest arguments in favor of a general cremation of the dead that it is possible to present. They also remind us of the boutade *of the Saturday Review, "that to be really Medieval, one should have no body; to be really modern, one should have no soul"; and it will be well to remember that if we do not quite accept these demonic apparitions we shall subject ourselves to the criticism of the modern mystic, Dr. Carl du Prel, who thus speaks of those who deny the miraculousness of stigmatization: "For these gentleman the bounds of possibility coincide with the limits of their niggardly horizon; that which they cannot grasp either does not exist or is only the work of illusion and deception."*

Notes
1. *Foster's Observations During a Voyage Around the World.*
2. *Primitive Culture.*
3. *Cited from Götze's Russ., Volkls., p. 62.*
4. *Cited by Calmet.*
5. *Tablet K 162, in British Museum.*
6. *Cited by Calmet.*
7. *Rhode Island has the largest population to the square mile of any State in the Union. The town of* Exeter, *before mentioned, incorporated in 1742–43, had but 17 persons to the square mile in 1890, and in 1893 had 63 abandoned farms, or one fifth of the whole number within its limits.* Foster, *incorporated in 1781 and taken from Scituate (which was settled by Massachusetts emigrants in 1710), had in 1890 a population of 1,252, and in 1893 had eight abandoned farms, Scituate having fifty-five.* North Kingston *had 76 persons to the square mile in 1890. Mr. Arnold, in his history of the State, says that "South Kingston was in 1780 by far the wealthiest town in the State." It had a special provision made for the "maintenance of religion and education."*
8. *Teutonic Mythology.*

In the late nineteenth century, many writings appeared on the subject of consumption and its effects on the people of New England in regard to superstition, treatment and legends. Yet the people still based their afflictions on the work of a ghoul or demon that had taken over the body of one of their own, rising in spirit from the grave to feed in succession upon its living relatives.

1784

WILLINGTON, CONNECTICUT

No one is really sure when the belief took hold in New England that some supernatural force may have played a role in the deaths of family members due to the horrible disease once called consumption. The influx of various diverse cultures into the country at the time brought many beliefs in folklore and lifestyles that inevitably intermingled as the different nationalities began to coexist in the new land. Consumptive victims took on the appearance of what one might consider a ghoul of sorts, becoming gaunt, pale and many times bleeding from the mouth due to profuse coughing. The look of the grave upon them certainly made others wonder if they were making that transition from human to demon. No doubt, many feared that when the person finally succumbed to the horrible malady, he or she would return and feed on the living in some way or another.

So far, the earliest record of an exhumation and exorcism for what we now term vampirism in New England has been traced back to 1784. The story is found in the *Connecticut Historical Collection* by John Warner Barker, published in 1836. Barker details an eyewitness account of an exhumation in 1784 by a local citizen named Moses Holmes, who spoke of a foreign doctor he referred to as a "quack." The doctor prescribed a very unusual remedy for the family of Isaac Johnson of Willington, Connecticut. Barker narrates that on June 1, 1784, Holmes witnessed Mr. Johnson, along with two doctors, West and Grant, exhume the bodies of Johnson's two children in order to perform the prescribed cure on himself. Johnson had become ill with the wasting disease. One of the children had been buried for one year and eleven months, while the other had been dead for just about a year.

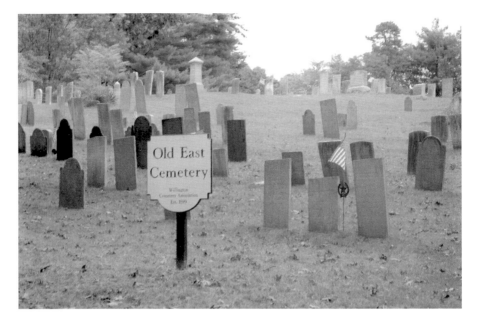

The Old East Cemetery in Willington, Connecticut, where Isaac Johnson and his family may have been buried.

The remedy was to dig up the bodies of the deceased and look for vines or sprouts that may be growing from the vitals. The next step was to remove the vitals, along with the vegetation, from the deceased and burn them. This would rid the family of their plight. Although the doctors found no sign of sprouts or vines within the coffin, Holmes did notice some small sprigs growing under one of the caskets. The account does not state whether the bodies were burned for good measure, but Holmes went on to note that the rest of the community should be made aware of the case so as to not be fooled by the doctor, whom he called an "imposter." This last comment might have come in light of the fact that Mr. Johnson died in 1785 from consumption.

According to research by folklorist Dr. Michael Bell, Isaac Johnson married Elizabeth Beal, and their two children were Amos and Elizabeth. All four were presumably buried at the Old East Cemetery, just off Route 74 in Willington. Both Dr. Bell and Connecticut State archaeologist Dr. Nicholas Bellantoni attempted to find their graves but were unable to locate any markers in the cemetery bearing such specific names.

Arlene and I, along with our friend Greg Wood, also attempted to locate any sign of the Isaac Johnson family within the Old East Cemetery.

Before beginning our trek, Greg quipped to his wife, Magin, "We're going vampire hunting."

Vampire hunting—not quite the nature of our expedition. Sure, in one light we were going searching for the graves of an alleged case of vampirism. I guess you could call that "hunting," but we did not have wooden stakes and holy water, not even garlic. We were not expecting to encounter a creature of the dark gliding stealthily among the tombs before turning into a bat and flying away or trying to bite us on the neck. We were simply searching for some gravestones in a cemetery. Legend tripping would probably fit the scenario more in definition, but vampire hunting sounds so much more dynamic. Arlene and I made a little joke about it, and we shuffled out to the car to begin our vampire hunt.

The cemetery was established in 1899, yet many of the graves date back to before the American Revolution. In fact, about two hundred men and boys from Willington served in the American Revolution. Thirty ardent citizens scurried over hill and hollow to help the cause in Lexington. There are several Johnson plots scattered among the burial ground, but none contains the graves of Isaac, Elizabeth or their children. We know through research by Ruth Shapleigh-Brown that roughly two-thirds of Connecticut's colonial graves are presumably long gone. Brown is the executive director of Connecticut Gravestone Network, an organization dedicated to preserving and protecting Connecticut's old burial grounds. I attended one of Brown's presentations and found it to be very enlightening. One reason that many of these graves are missing, according to Brown, is due to the fact that many of the settlers used wooden markers, which rotted away over time, or common fieldstones, which have sunken into the earth or were cleared away by later owners of the land who saw them as mere stones jutting up from the earth. The early settlers were mostly Puritans and did not believe in elaborate grave markers until much later. Even the final resting places of the founding fathers of some of the towns that bear their names are long lost.

In the case of the Johnson family, it seems rather unlikely that the markers were lost, as the existing stones seem to be well established. We even considered the time period in which the event was to have taken place in conjunction with the burials at the cemetery. Some of the burials predate the Johnson case and have proper markers. Even the Johnson plots have carved headstones, some of them also predating the time of the reported exhumation and exorcism. It seems strange that one whole family would be buried there, yet there would be no stones of any kind to mark their graves. The chance that wooden markers may have been

erected for the entire family seems improbable, but it is not altogether out of the question.

Another interesting fact that Ruth pointed out is the way old burial yards are arranged. Many of the grave sites are not in neat rows but are strewn about haphazardly. This is not due to carelessness or lack of planning but is more in line with the makeup of the New England landscape. The region is very rocky, and in some cases, digging a grave became an endeavor when a shovel hit an immense, unmovable boulder. The easiest thing to do was to relocate the site of the grave in hopes of finding easier ground to dig. This would account for many of the burials being out of line. One mistake that historical societies often make when cleaning these old cemeteries is to assume that time and the movement of the earth has caused these stones to shift. Preservationists pull them up and replant them in a line, in keeping with what they know from today's burial customs. Of course, this means that the stones are no longer marking actual grave sites. In some cases, Ruth found that a stone had been relocated a good distance from the actual gravesite, making it appear that a stone was missing from a grave when in reality it was several feet away, looking like it belonged to another plot.

There are certain areas, especially near a few of the Johnson plots, where there is open space with no tombstones. Could they be unmarked graves? Could the stones have been removed for some reason and never replaced? Could they have been temporary markers that may have been mistaken for fieldstones and discarded?

All of these questions and more come into play when looking for the Johnson plot. The other question that crosses one's mind is the idea that maybe it is the wrong cemetery altogether. We checked to see if Willington may have been part of another town or if another town may have once been part of Willington. A check of when Willington was established proved that it was incorporated in May 1727, well before the exhumations took place. The surrounding towns were also well established before the Johnson incident—Tolland in May 1722, Mansfield in October 1702, Stafford in 1719, Union in 1734 and Ashford in 1714. The reason I mention this as an important factor is that some larger towns were often divided up into smaller towns and renamed, making records hard to locate. It was not uncommon for towns to be annexed into smaller segments for, among other reasons, ease of government or lack of meetinghouses. This practice went on well into the nineteenth century. I had the pleasure of speaking with Dr. Bellantoni on the subject, and I found that he had come to the same conclusion long before that the Johnson plot might be on their old property; this is why no one could find their graves in the Old East Cemetery.

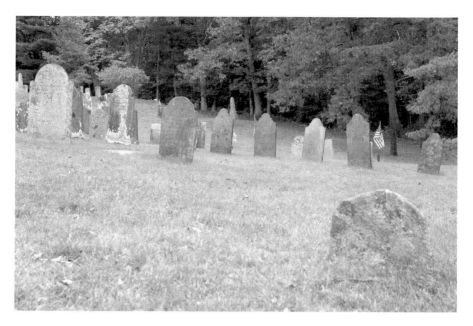

One of the Johnson plots in the Old East Cemetery in Willington, Connecticut. Note the grassy space in the foreground.

For now, we have only scant records that state that an exhumation took place in an attempt to rid the Johnson family of their plight. This case is also the first time that a vine being part of the cure for vampirism is brought up. This idea would surface several years later in Vermont and, still later, in New Hampshire. However, cases from the mid- to late nineteenth century do not point to vines or the growth of any plants in or near coffins as a sign of ghoulish activity.

Was the Willington incident the first actual case of vampirism, the one that set the standard for scores of families digging up their loved ones in search of some spectral ghoul that fed on the living? No one is sure, but the case does fit the scenario of what would transpire for the next one hundred years, when medicine failed and folklore took over.

It is important to note that in the research of tuberculosis (consumption) before and at the time of this foreign doctor's remedy, studies proved that consumption could be diagnosed but still could not be effectively treated.

1793

DUMMERSTON, VERMONT

Arlene and I had no problem finding the Burnett Cemetery just off of Route 5, across from the Dummerston School. Although the burial ground was not a great expanse, there were plenty of colonial gravestones that would keep us busy searching for the one that bore Lieutenant Spaulding's name.

Arlene and I alit from our vehicle while eying the best place to start our search. Arlene took the left side, and I took the right. I immediately noticed that the right side of the cemetery was higher in elevation than the rest of the grounds. That's when something from David L. Mansfield's *The History of the Town of Dummerston* (1884) came to me. Spaulding had requested to be buried on higher ground, as the marsh and wetlands made for poor burial. Based on that statement, it made sense for us to search the right side of the cemetery. Also, since Spaulding had been a veteran of a few wars, one of the key things we looked for was a flag or plaque of some sort that the town may have placed near his grave.

The very first stone at the edge of the cemetery was, in fact, Lieutenant Spaulding's marker. It was a much newer design than would have been common in the lieutenant's time. Among the other stones were those of some of the first settlers of Dummerston. The burial yard is a wonderful historic cemetery worth visiting for the knowledge gained on the founding of a quintessential Vermont hamlet.

Lieutenant Leonard Spaulding was a celebrated war hero of the French and Indian War and the Revolutionary War. He was later elected as the first representative to the Vermont legislature. He was certainly not a person

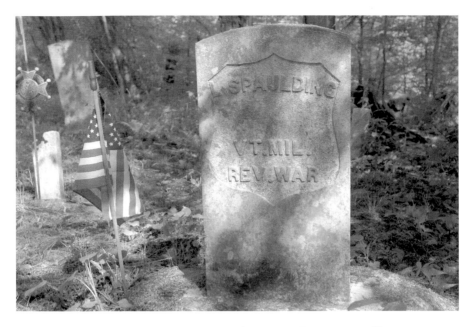

Lieutenant Spaulding's marker at the Burnett Cemetery in Dummerston, Vermont.

of low intellect or one to fall prey to superstition. In 1756, he married Margaret Sprague Love of Providence, Rhode Island. He served at Crown Point in 1758. Spaulding later settled in Putney about 1768. When his home burned down in 1771, he removed to a farm in Westmoreland, New Hampshire. He remained there for less than a year before moving his family to Dummerston. Despite being wounded during a conflict at Westminster on March 13, 1775, he still continued to fight in the Revolution while his wife and sons, Reuben and Leonard Jr., tended to the farm. Spaulding fought in the famous Battle of Bennington. During the battle, his wife was reportedly out in the garden when she heard the loud booms from cannons some forty miles away. She did not know that a battle was going on, nor did she know that her husband was in the thick of it. Lieutenant Spaulding later represented Dummerston in the General Assembly in 1778, 1781, 1784, 1786 and 1787. His accomplishments and stature as a Vermont statesman speak for themselves.

All of these facts can be found in David L. Mansfield's *History of the Town of Dummerston*. Mansfield also writes of a strange ritual that took place in order to rid the Spaulding family of the malady that was taking each member of the family, one by one.

Several of Spaulding's children died of consumption at a young age. Mary died on May 12, 1782, at the age of twenty. Esther followed her on July 1783 at the age of sixteen. Timothy, twin brother to John, died on June 13, 1785. Most of the children are buried at the Dummerston Center Cemetery. On July 17, 1788, Lieutenant Spaulding died at the age of fifty-nine. As per request, Lieutenant Spaulding was buried in a graveyard east of what is presently known as Slab Hollow. The burial ground is known as Burnett Cemetery, just west of Route 5 on School House Road. This was due to the fact that his intended resting place had turned into a bog, and burial was out of the question. There is a marker to his memory at the far end of the burial yard.

It was less than two years after the lieutenant's death that thirty-one-year-old Betsey joined her father and brothers, followed by thirty-two-year-old Leonard Jr., on September 3, 1792. At that point, family members, with nowhere else to turn, began to wonder if a supernatural force was preying on them. Historical records are a bit hazy at this point, but some scholars state that it was John Spaulding, twin brother to Timothy, who set the wheels in motion with his death on March 26, 1793.

Renowned author and investigator Joe Nickell of the Committee for Skeptical Inquiry took a special interest in Vermont vampires. His research led him to the discovery that the Spaulding family members resting in the Dummerston Center Cemetery were not buried in the order they died. He also suggested that an exorcism might have been performed on Josiah, who died almost five years after Leonard Jr. Since there are no specific names given in Mansfield's work, it is difficult to determine who was the actual "vampire" of the family.

When one of the remaining two daughters took ill, the family apparently leaned toward the vampire theory and the much-needed exorcism that would accompany it. Mansfield writes:

> *Although the children of Lt. Spaulding, especially the sons, became large, muscular persons, all but one or two died under 40 years of age of consumption, and their sickness was brief.*
>
> *It is related to those who remember the circumstance; after six or seven of the family had died of consumption, another daughter was taken, it was supposed, with the same disease. It was thought she would die, and much was said in regard to so many of the family's dying of consumption when they all seemed to have the appearance of good health and long life. Among the superstitions of those days, we find it was said that a vine or root of*

some kind grew from coffin to coffin, of those of one family, who died of consumption, and were buried side by side; and when the growing vine had reached the coffin of the last one buried, another one of the family would die; the only way to destroy the influence or effect, was to break the vine; take up the body of the last one buried and burn the vitals, which would be an effectual remedy: Accordingly, the body of the last one buried was dug up and the vitals taken out and burned, and the daughter, it is affirmed, got well and lived many years. The act, doubtless, raised her mind from a state of despondency to hopefullness [sic].

This is another instance where the presence of a vine appears in a documented case of vampirism in New England. In the Johnson case, it was explicitly stated that the vines or sprouts would be growing from the remains, and in the Spaulding case, the vine was said to be growing from coffin to coffin. It is this peculiar reference to the vine that prompts me to believe that this case in provocation may predate the Rachel Burton case by a few months, as the vine does not show up in accounts of the latter. Perhaps in the cases that followed there was no vine or root growing across or within the coffins or they were not buried exactly side by side. In such events, the vine theory would become less prevalent than the actual physical features that the exhumed showed when taken from the grave. If this idea came into play in later cases, it was not added to the documentation, with the exception of two New Hampshire cases where the "vampire hunters" were actually looking for such growth on the deceased more than any other sign as evidence that an evil, consumptive-spreading ghoul had taken over the corpse.

In any event, the vine was cut, the body of the last interred was exhumed and the vitals were cut out and burned. The daughter, strangely enough, recovered from her illness and, according to Mansfield's research, went on to live a long, healthy life. Mansfield does not name the daughter, but we can guess that it may have been Anna, who died on January 13, 1849, at the age of eighty-one years, nine months and six days. Reuben and Josiah both died young—Reuben, on January 20, 1794, at the age of twenty-eight; and Josiah, on December 3, 1798, at the age of twenty-seven. Margaret Spaulding lived to be ninety-four. She died on May 21, 1827, and is buried next to Anna, although there is no known gravestone to mark her plot.

1793

MANCHESTER, VERMONT

She became ill soon after they were married and when she was in the last stages of consumption, a strange infatuation took possession of the minds of the connections and friends of the family. They were induced to believe that if the vitals of the first wife could be consumed by being burned in a charcoal fire it would effect a cure of the sick second wife. Such was the strange delusion that they disinterred the first wife who had been buried about three years. They took out the liver, heart, and lungs, what remained of them, and burned them to ashes on the blacksmith's forge of Jacob Mead. Timothy Mead officiated at the altar in the sacrifice to the Demon Vampire who it was believed was still sucking the blood of the then living wife of Captain Burton. It was the month of February and good sleighing. Such was the excitement that from five hundred to one thousand people were present. This account was furnished me by an eyewitness of the transaction.
—*Judge John S. Pettibone (1786–1872),* History of Manchester, Vermont

Captain Isaac Burton, a deacon of the Congregational Church, married Rachel Harris on March 8, 1789. Rachel was a young and vigorous woman of stunning beauty. Less than a year after the couple exchanged vows, Rachel contracted consumption. Her health declined swiftly, and on February 1, 1790, consumption took her to the grave.

A short time following Rachel's interment, the captain married his second wife, Hulda Powell, on April 4, 1791. She, too, was a handsome woman with a friendly nature. She also became ill within a short time and began to show

signs of consumption. As her health began to decline in a swift manner, the captain knew all hope was lost.

It was then that a strange belief took hold of the family and friends of Captain Burton. They concluded that the first wife was coming back from the grave and feeding on the lifeblood of Hulda, thus creating her consumptive condition. They were convinced that if the vitals of the first wife were reduced to ashes, Hulda would be cured of the terrible wasting illness.

Rachel had been buried for three years when the deed was carried out. It is reported that almost one thousand people showed up for the gruesome exorcism. What remained of her heart, lungs and liver were placed on the blacksmith forge of Jacob Mead. The decomposed liver, heart and lungs were then reduced to ashes. Timothy Mead presided over the blessing of the remains in an attempt to purge the demonic disease that gripped Hulda. This form of medicine did not work, as Hulda succumbed to the dreaded consumption on September 6, 1793. It is not clear whether she was made to drink Rachel's ashes with some form of medicine. The idea of bringing in the blacksmith forge is a fascinating aspect in this case, as blacksmiths historically were thought to be, in a sense, more mystical than ordinary people. Their use of fire, iron and horseshoes gave them a magical edge over the supernatural. Vampires or vampirism, according to superstition, can be exorcised in the presence of iron, hence the role of the blacksmith in burning the vitals on his forge.

Joe Nickell paid a visit to Manchester to find out some facts about the Burton case. In his impressive research, he was able to officiate the dates pertaining to the Burton family mentioned above. He also found that Isaac Burton and his fourth wife were relocated from the Old Village Green, where the courthouse now sits, to the Dellwood Cemetery. Many unmarked graves are still believed to be in the green, including that of Rachel.

When Judge John Pettibone wrote about the account, he stated that it was "furnished" to him by an eyewitness. He also stated that the exorcism took place in February, as there was "good sleighing." The only problem that arises is that in February the ground would most likely have been frozen, and digging—especially in 1793—would have been extremely difficult. They must have been pretty desperate to rid their host of the affliction that made her suffer so. If this case predates the Spaulding case—and according to the dates given, it does—then what became of the vine theory? Pettibone, in his writing, stated that the month was February, but he also acknowledged that an eyewitness related the account to him. Any historian, folklorist or researcher soon comes to find out that dates are often mistaken when translated or recounted. That is not to say definitively that this is the case here, but keep this in mind when looking for historical data.

1796

CUMBERLAND, RHODE ISLAND

The following excerpt is from the Cumberland Town Council meeting held on February 8, 1796. It is in regard to resident Stephen Staples, a prominent farmer whose daughter died of consumption. In the council records, it states that the council had been "specially called and held" on that particular day. Members of the council present at the time were Mr. John Lapham, Mr. Jason Newell, Captain Benjamin S. Westcott and Mr. Benjamin Singly.

> *Mr. Stephen Staples of Cumberland appeared before this council and prayed that he might have liberty granted unto him to dig up the body of his dofter* [daughter] *Abigail Staples late of Cumberland single woman deceased in order to try an experiment on Livina Chace wife of Stephen Chace which said Livina was sister to the said Abigail deceased which being duly considered it is voted and resolved that the said Stephen Staples have liberty to dig up the body of the said Abigail deceased and after trying the experiment as aforesaid that he bury the body of the said Abigail in a deasent* [sic] *manner.*

This is a rather curious entry, as the family patriarch actually asks the town council for permission to dig up one daughter in order to save another daughter. If it was in typical Rhode Island fashion, the graveyard was on Staples's property to begin with, so it was not like he would be stealing out to a common burial ground to perform this gruesome task. Farmers would designate the least useful piece of property to inter their loved ones. We must

remember that there were no supermarkets or convenience stores at this time. Farming the rocky New England soil was hard, and there was never a guarantee that the land was going to be fertile. Every inch of good planting soil was needed for the living. If the crops failed or did not produce well, the family could look forward to a hungry winter.

There is no further record regarding what happened as a result of this meeting. If Abigail were disinterred, she would have been dead about one year. According to Dr. Michael Bell's research, Stephen Staples died on April 8, 1815. Abigail Staples was born on January 26, 1773. Assuming she had passed within a year of the 1796 request, she would have been between twenty-two and twenty-three years old. The Staples lot, Cumberland Historical Cemetery #17, is set on a small hill ten feet north of Nate Whipple Highway amongst bramble and brush. There are twelve burials with four inscribed stones from 1799 to 1840. Most of the markers are fieldstones, as was common in colonial times. This leaves the actual grave sites of Mr. Staples and Abigail up to conjecture. There is one story of a stone actually being stolen by someone who thought it was Abigail's. The cemetery was transcribed in the Arnold records, volume eight, page ninety-eight. The transcription makes note of three unmarked graves in addition to the three listed—an interesting entry when considering the town council minutes recorded in 1796.

As for Mr. Stephen Staples, not a whole lot is known about him. I searched for a birth record but could not find one. I did find in the vital records at the Greenville Public Library that he married Susannah Bartlett on April 26, 1762. According to the same vital records, Lavina Staples was born on June 23, 1762, but there was no record of her death to speak of. This is basically the same as Dr. Bell's findings at the time of his research. All libraries have pretty much the same volumes to peruse. Mr. Staples was a farmer, and there is a road named after the Stapleses near the burial ground. The big claim to fame is the town council entry that has made history and continues to keep researchers on the trail of what the outcome of his request may have been.

In searching for the Stephen Staples lot, it was already clear from my research that there was going to be few legible stones. Armed with a cemetery number and this minute amount of facts, Arlene and I headed out to Cumberland. This time, we took our friend Ron Kolek Jr. of the New England Ghost Project, based out of Dracut, Massachusetts. Ron is an avid researcher of all New England history and folklore, so naturally vampires piqued his interest. He was also recording interesting cemeteries for a book project he had been working on. We took him to Exeter Historical Cemeteries

The Staples lot, Cumberland, Rhode Island Historical Cemetery #17, is now overgrown and the fieldstone grave markers are barely noticeable.

Only a few graves in Historical Cemetery #17 have actual carved stones dating to the mid-nineteenth century. The rest are fieldstone markers dating back to colonial times.

#14 and #22. We then trekked out to Foster to Historical Cemetery #142 before having lunch and getting on the highway to Cumberland.

Maneuvering through the briars and brush was a small feat in itself. Once inside the family lot, we noticed, as per the cemetery records, that there were only a few stones with inscriptions on them dating back to the nineteenth century. We had hoped there would be some sort of carving on the fieldstones that may have indicated where Abigail, Livina or even Mr. Staples was interred. Any inscriptions or initials, however, had been long eroded, and the small stones, in some cases, barely protruded from the earth or were hidden in the overgrowth of shrubs and brush. This was truly a colonial family burial site.

1799

EXETER, RHODE ISLAND

In 1799, an Exeter apple farmer named Stutley Tillinghast had a foreboding dream. He envisioned his orchard, abundant and vast with the juiciest of enticing fruit, suddenly turn black, and before he knew it, half of his trees had withered and died. This dream, according to legend, bothered the farmer, for he knew it was a sign. Still, he kept the dream to himself. Stutley and his wife, Honor, were blessed with fourteen children, as well as a bountiful harvest each season. Before long, their daughter Sarah became ill. She began a rapid decline with the telltale signs of consumption. The doctors could do nothing about her condition, which worsened each day. In no time, the dreaded disease beckoned Sarah to her grave in 1799 at the age of twenty-two.

Soon after, another of the children became ill, complaining that each night Sarah was visiting her and sucking the life from her body. One by one, the Tillinghast children succumbed to the wasting illness, each one, in turn, complaining that it was Sarah visiting them in the dark hours of the night, stealing what little life they had left in them. When the seventh child, one of the sons, took ill, family members and neighbors became convinced that a vampire was at work. The children were exhumed and examined. Most of them were well on their way into decomposition. Sarah, the first to die, still had rosy cheeks and the color of the living on her flesh. Her eyes were open, and her hair and nails appeared to have grown. This was a sure sign that they had found their vampire. The family cut out Sarah's heart and burned it in front of the house, feeling confident that there would be no more nightly attacks. The last child passed away despite the attempted

cure. It was widely concluded that he was too far into his illness to be saved, thus fulfilling Stutley's dream of losing half of his orchard in the form of his children.

I first came across the story of Stutley Tillinghast in an *Old Rhode Island* magazine from October 1992. As I read this account in several other publications, it became evident that there must have been a starting point for reference on this case. This was, in fact, what got me interested in New England vampire legends. Another influence was James Earl Clauson's book, *These Plantations*. I came across the book when I purchased a pamphlet by Rhode Island historian Margery Matthews on the Ramtail Factory. The book was mentioned in the bibliography, prompting me to find it in a local library or bookstore. I was actually looking for information on the ghost story regarding the factory, but the book held so many more interesting legends, including those of Rhode Island vampires, that I bought a used copy for a mere ten dollars and read it cover to cover in one sitting. Clauson mentions Sidney Rider in his 1937 book. His chapter "Vampirism in Rhode Island" cites Rider's account of the Tillinghast case. The story from *Old Rhode Island* is mostly the same, showing similar sources, but there had to have been an earlier, more in-depth version for them to feed on. It appeared that Rider was that source.

I researched Sidney Rider's writing and found reference to his narrative on www.quahog.org. I e-mailed Christopher Martin, who hosts the website, and got an immediate response. He was more than happy to assist me on my quest to find the documentation so I could study it. Chris was ready to help and produced a copy of Rider's narrative on the Tillinghast case within minutes. He also gave me information on Sidney Rider.

Sidney Rider (1833–1917) was a Providence bookseller and amateur historian. In 1883, he began to publish a biweekly compilation of "literary gossip, criticisms of books, and local historical matters connected with Rhode Island," which he called *Book Notes*. The main purpose of these circulars was to promote and sell more books from his shop at 17 Westminster Street. He produced his paper for thirty-three years, keeping the literary community enlightened on his views, news and other interesting historical matters. Of particular interest for this tome was the *Book Notes* for Saturday, March 31, 1888, volume five. Although it talks a bit more about vampires, the following excerpt deals directly with the Tillinghast account:

> *At the breaking of the Revolution there dwelt in one of the remoter Rhode Island towns a young man whom we will call Stukeley. He married an*

excellent woman and settled down in life as a farmer. Industrious, prudent, thrifty, he accumulated a handsome property for a man in his station in life, and comparable to his surroundings. In his family he had likewise prospered, for Mrs. Stukeley meantime had not been idle, having presented her worthy spouse with fourteen children. Numerous and happy were the Stukeley family, and proud was the sire as he rode about the town on his excellent horses, and attired in his homespun jacket of butternut brown, a species of garment which he much affected. So much, indeed, did he affect it that a sobriquet was given him by the townspeople. It grew out of the brown color of his coats. Snuffy Stuke they called him, and by that name he lived, and by it died.

For many years all things worked well with Snuffy Stuke. His sons and daughters developed finely until some of them had reached the age of man or womanhood. The eldest was a comely daughter, Sarah. One night Snuffy Stuke dreamed a dream, which, when he remembered in the morning, gave him no end of worriment. He dreamed that he possessed a fine orchard, as in truth he did, and that exactly half the trees in it died. The occult meaning hidden in this revelation was beyond the comprehension of Snuffy Stuke, and that was what gave worry to him. Events, however, developed rapidly, and Snuffy Stuke was not kept long in suspense as to the meaning of his singular dream. Sarah, the eldest child, sickened, and her malady, developing into a quick consumption, hurried her into her grave. Sarah was laid away in the family burying ground, and quiet came again to the Stukeley family. But quiet came not to Stukeley. His apprehensions were not buried in the grave of Sarah.

His unquiet quiet was but of short duration, for soon a second daughter was taken ill precisely as Sarah had been, and as quickly was hurried to the grave. But in the second case there was one symptom or complaint of a startling character, and which was not present in the first case. This was the continual complaint that Sarah came every night and sat upon some portion of the body, causing great pain and misery. So it went on. One after another sickened and died until six were dead, and the seventh, a son, was taken ill. The mother also now complained of these nightly visits of Sarah. These same characteristics were present in every case after the first one.

Consternation confronted the stricken household. Evidently something must be done, and that, too, right quickly, to save the remnant of this family. A consultation was called with the most learned people, and it was resolved to exhume the bodies of the six dead children. Their hearts were then to be cut from their bodies and burned upon a rock in front of the

house. The neighbors were called in to assist in the lugubrious enterprise. There were the Wilcoxes, the Reynoldses, the Whitfords, the Mooneys, the Gardners, and others. With pick and spade the graves were soon opened, and the six bodies brought to view. Five of these bodies were found to be far advanced in the stages of decomposition. These were the last of the children who had died. But the first, the body of Sarah, was found to be in a very remarkable condition. The eyes were opened and fixed. The hair and nails had grown, and the heart and the arteries were filled with fresh red blood. It was clear at once to these astonished people that the cause of their trouble lay there before them. All the conditions of the vampire were present in the corpse of Sarah, the first that had died, and against whom all the others had so bitterly complained. So her heart was removed and carried to the designated rock, and there solemnly burned. This being done, the mutilated bodies were returned to their respective graves and covered. Peace then came to this afflicted family, but not, however, until a seventh victim had been demanded. Thus was the dream of Stukeley fulfilled. No longer did the nightly visits of Sarah afflict his wife, who soon regained her health. The seventh victim was a son, a promising young farmer, who had married and

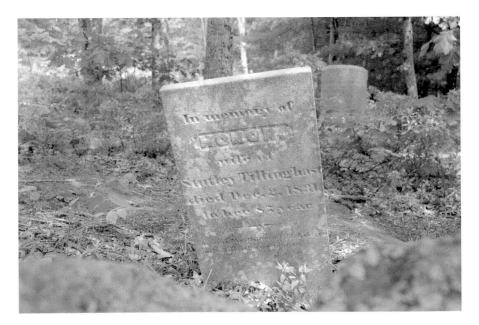

The grave of Honor Tillinghast in Exeter, Rhode Island Historical Cemetery #14, mother of Sarah Tillinghast. The epitaph on the stone reads, "She was the mother of 14 children and all lived to grow up."

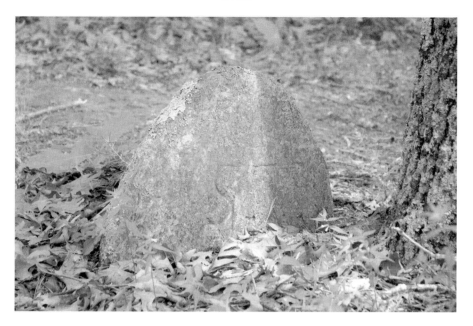

This gravestone is presumably that of Stutley Tillinghast as it sits on the right side of Honor's. Note the "ST" carved in the stone.

lived upon a farm adjoining. He was too far gone when the burning of Sarah's heart took place to recover.

In actuality, there were five children who became ill and died in rapid succession. Four of them—Sarah, Ruth, Anstis and James—died in 1799, and Hannah passed in 1800. The seven children dying in the story coincides with half of Stutley's fourteen children, thus giving more impetus to the legend. Rider does not divulge his sources in his writing, so we are left to believe that much of it was probably handed down by word of mouth.

The name Stukeley as it appears in *Vital Records of Rhode Island* by James Arnold also appears in records as Stutley, Stutely and Stutly Tillinghast, who, according to cemetery records, was the son of Pardon Tillinghast of West Greenwich and was born on November 24, 1741, in Warwick. He died in 1826. His name also appears in the 1790 state census as Stukely, but in the 1800 state census it is Stutly. Honor Tillinghast, born on January 6, 1745, in accordance with Rider's narration, did regain her health; she died on December 2, 1831, just shy of her eighty-seventh birthday. Sarah, according to Dr. Michael Bell's research and that written in the *Vital Records of Rhode*

Island, was not the oldest child of the family, but the tenth oldest of fourteen. She was born on October 10, 1777. Ruth was nineteen when she died in 1799, and Sarah was twenty-two. James, born on August 21, 1786, was about thirteen when he passed, and Anstis, born on January 18, 1782, was seventeen. Hannah, who reportedly died in 1800, was, according to records, born on December 26, 1772. Anstis is, by modern standards, a masculine name. Taking this into consideration, the "promising young farmer" Rider refers to could have been Anstis. However, birth records indicate that Anstis was female. James, who reportedly passed away at thirteen years of age, could also account for this part of the text if the word "promising" is taken to mean a budding young man learning the skills of farming, much like an apprentice, in order to someday take over the family farm. However, thirteen seems young to be married and living on an adjoining farm. In *Food for the Dead,* Dr. Bell puts forth the possibility that the promising young farmer may have been Hannah's husband, Joseph Hoxsie, as Hannah died in 1800 after three years of marriage. Could it be that the information given to Sidney Rider was slightly misrepresented or the facts jumbled over time? This and other questions remain.

Hand-hewn headstones and footstones mark a row of graves. These are most likely the Tillinghast children, who died in rapid succession in 1799 and 1800, thus leaving the family with little or no time to procure proper stones. Sarah is buried somewhere among them.

When examining Exeter Historical Cemetery #14, one can see a row of fieldstone graves where most likely the children who died within a year of one another were buried. In those days, stonecutters were few and far between, and perhaps the family had to wait for proper stones or was financially unable to have that many stones made at once. Either way, the fieldstones are scattered among regular inscribed stones in the cemetery, which consists of twenty-five burial sites with fifteen inscribed stones dating from 1831 to 1919. There are actually six unmarked fieldstones. The cemetery sits twenty feet east of Forest Hills Drive off Route 102, up a little hill and among brush and trees. Please obey all regulations in regard to historical cemeteries and be respectful of the property when visiting.

CIRCA LATE 1700 TO EARLY 1800

GRISWOLD, CONNECTICUT

New discoveries of those who were exhumed for vampirism have continued to occur well into the present. Some are found by thorough research and leads coming from descendents of families who were convinced an evil was trying to wipe them out, and others are found by complete accident. In November 1990, three young boys were sliding down a privately owned sand and gravel pit in Griswold, Connecticut. The boys were having a wonderful time doing what young children do, having good clean fun; that is, until a few skulls rolled alongside one of them as he descended the embankment. The frightened boys dashed home to tell their parents, who in turn called the authorities.

The police arrived on the scene not knowing what to expect. It was speculated that the area could have been a burial site for a serial killer, but there were no such cases in the region to account for that theory. Upon examining the skulls, they realized that an archaeologist would be more of a logical choice to help identify their find. Connecticut State archaeologist Dr. Nicholas Bellantoni was called to the scene, and after some investigating, he found that the children had discovered an abandoned colonial cemetery literally falling out of the side of the eroding sandbank. The fieldstone markers had been buried over time or were nonexistent. But who was buried there?

With Dr. Bellantoni on hand and an invitation extended to forensic anthropologist Paul Sledzik, curator of the Anatomical Collections at the National Museum of Health and Medicine in Washington, D.C., excavations began in an attempt to remove and relocate the remains to another cemetery

down the road. They found twenty-nine burials in all—fifteen sub-adults, six adult males and eight adult females—but there was one grave in particular that made everyone stop and stare in disbelief. Of the numbered burials, burial number 4 was the oddest. It had been lined on the sides and top with stone slabs. When they removed the slab, they found "JB-55" marked on the top of the coffin with brass tacks. This was concluded to be the possible initials and age of death of the deceased. When the lid of the coffin was opened, the stunned throng found that the skeleton's skull and thigh bones had been arranged in a "skull and crossbones" manner on top of the ribcage, which had also been rearranged in order for the skull to fit in such a place. Oddly enough, Dr. Michael Bell, who because of his knowledge of vampire folklore was called in to examine the strange excavation, stated that the skeleton of "JB" was the best preserved in the burial lot. The skeleton was sent to Washington, D.C., for analysis.

Interred alongside of "JB" were two other similar burials with tacks nailed into their coffins that may have been related. One, "IB-45," was concluded to be a female, and a child, "NB-13," was buried alongside her. There were several other burials of young children in a cluster, suggesting that a disease, perhaps smallpox or measles, which were prevalent about the time of the burials, may have spread through the family. Research by Dr. Bellantoni showed that the cemetery belonged to the Walton family. Lawrence and Margaret Walton moved from Boston about 1690 and started a farm in what was then part of Preston. One of their five children, John, born in 1694, became a well-respected preacher of the Congregationalist Church. It was their second son, Nathan, and his wife, Jemima, who purchased a small plot of land from their neighbor in 1757 for use as a family burial ground. The Walton family lived on the homestead and used the burial ground well into the nineteenth century, until they decided to move westward to more fruitful farmlands. Then, according to Dr. Bellantoni, another unidentified family used the burial ground for a short period of time. This could be where JB and his family come into the picture, or they may have been related to the Waltons.

In "Biological and Biocultural Evidence for the New England Vampire Folk Belief" by Nicholas Bellantoni and Paul Sledzik, written in 1994 for the *American Journal of Physical Anthropology*, it was concluded, based on their research, that JB died of consumption or some form of pulmonary tuberculosis. Several years later, one of the family members became ill. They feared that JB might have been returning from the grave to feed on them. They attempted to burn the heart in typical New England fashion, but when they opened the grave, there was nothing left but a skeleton. They resorted

to an alternative remedy of rearranging the skull and femur bones into a skull and crossbones pattern to put an end to the illness that was afflicting them. Dr. Bellantoni based his conclusion that an exorcism for vampirism was most likely performed on three pieces of evidence: the arrangement of the bones, the paleopathological evidence of tuberculosis or a chronic pulmonary infection producing the same physical appearance on the ribs of the skeleton and the historical accounts of the vampire folk belief and remedies that were practiced at about the same time in New England.

I had the honor and pleasure of speaking with Dr. Bellantoni about the findings at the Walton burial lot. He found it very intriguing to have actually come across such a rare find by accident. Dr. Bellantoni stated that JB-55 was, to his knowledge, the only physical evidence found thus far of the New England vampire scare.

The remains found in the Walton lot were buried in the Hopewell Cemetery, along the Patchaug River, in an unmarked area to keep vandals from digging up the graves in search of the alleged vampire.

We once again find a tie to Rhode Island in this particular case. The town of Griswold was originally set out in the North Society of Preston.

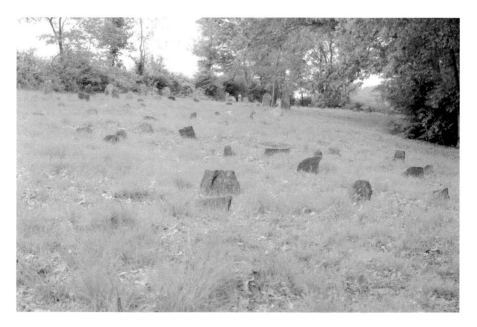

Hopewell Cemetery in Griswold, Connecticut, where the remains of the Walton burial lot were relocated in an undisclosed location.

Griswold, consisting of many Rhode Island emigrants, petitioned the state to be incorporated as a separate town in 1815. In October of that year, the Connecticut State Assembly granted that request, making Griswold an official town. Border disputes between Griswold, Preston and Voluntown continued, however, until 1872, when the final boundaries of the town were recognized. Many of the locals considered the Rhode Island settlers to be crude, uneducated and socially inept.

It seems weird—almost surreal—in this day and age to have such evidence literally pop up in front of us, but New Englanders have a lot of eerie skeletons in their family closets and even more in their graveyards.

1807

PLYMOUTH, MASSACHUSETTS

Every New England state had at least one documented case of exhumation and exorcism for vampirism. This next account took place in Plymouth, Massachusetts. The land where the pilgrims settled (they actually first landed at Provincetown but a month later shoved off for more bountiful land) was apparently once an abode for a creature of the night. The author of the account adds a poem that he wrote for extra measure. There are no names given, like so many other New England vampire writings, but the story remains true to the historic essence we have come to know in New England. I am guessing that the writer left out specific names for the sake of anonymity on the part of the people involved. The article appeared in the very first issue of the *Old Colony Memorial and Plymouth County Advertiser* dated May 4, 1822. It also appears in Christopher Rondina's *Vampire Hunter's Guide to New England*, Michael Bell's *Food for the Dead* and Jeff Belanger's *Weird Massachusetts*. I present it here once more in its entirety for the sake of record and thoroughness.

> *In that almost insulated part of the state of Massachusetts, called Old Colony or Plymouth County, and particularly in a small village adjoining the shire town, there may be found the relic[k]s of many old customs and superstitions which would be amusing, at least to the antiquary. Among others of less serious cast, there was, fifteen years ago, one which, on account of its peculiarity and its consequence, I beg leave to mention.*
>
> *It is well known to those who are acquainted with that section of our country, that nearly one half of its inhabitants die of a consumption,*

occasioned by the chilly humidity of their atmosphere, and the long prevalence of easterly winds. The inhabitants of the village (or town as it is there called) to which I allude were peculiarly exposed to this scourge; and I have seen, at one time, one of every fifty of its inhabitants gliding down to the grave with all the certainty which characterizes this insidious foe of the human family.

There was, fifteen years ago, and is perhaps at this time, an opinion prevalent among the inhabitants of this town, that the body of a person who died of a consumption, was by some supernatural means, nourished in the grave of some one living member of the family; and that during the life of this person, the body retained, in the grave, all the fullness and freshness of life and health. This belief was strengthened by the circumstance, that whole families frequently fell a prey to this terrible disease.

Of one large family in this town consisting of fourteen children, and their venerable parents, the mother and the youngest son only remained—the rest within a year of each other had died of the consumption.

Within two months from the death of the thirteenth child, an amiable girl about sixteen years of age, the bloom, which characterized the whole of this family, was seen to fade from the cheek of the last support of the heart-smitten mother, and his broad flat chest was occasionally convulsed by that powerful deep cough which attends the consumption in our Atlantick States.

At this time as if to snatch one of this family from an early grave, it was resolved by a few of the inhabitants of the village to test the truth of this tradition which I have mentioned, and, which the circumstances of this afflicted family seemed to confirm. I should have added that it was believed that if the body thus supernaturally nourished in the grave, should be raised and turned over in the coffin, its depredation upon the survivor would necessarily cease. The consent of the mother being obtained, it was agreed that four persons, attended by the surviving and complaining brother should, at sunrise the next day dig up the remains of the last buried sister. At the appointed hour they attended in the burying yard, and having with much exertion removed the earth, they raised the coffin upon the ground; then, displacing the flat lid, they lifted the covering from her face, and discovered what they had indeed anticipated, but dreaded to declare. Yes, I saw the visage of one who had been long the tenant of a silent grave, lit up with the brilliancy of youthful health. The cheek was full to dimpling, and a rich profusion of hair shaded her cold forehead, while some of its richest curls floated upon her unconscious breast. The large blue eye had scarcely lost its brilliancy, and the livid fullness of her lips seemed almost to say, "Loose me and let me go."

In two weeks the brother, shocked with the spectacle he had witnessed, sunk under his disease. The mother survived scarcely a year, and the long range of sixteen graves, is pointed out to the stranger as an evidence of the truth of the belief of the inhabitants. The following lines were written on a recollection of the above shocking scene:

I saw her, the grave sheet was round her,
Months had passed since they laid her in the clay;
Yet the damps of the tomb could not wound her,
The worms had not seized on their prey.
O, fair was her cheek, as I knew it.
When the rose all its colours there brought;
And that eye, - did a tear then bedew it?
Gleame'd like a herald of thought.
She bloom'd, though the shroud was around her,
Locks o'er her cold bosom wave,
As if the stern monarch had crown'd her,
The fair speechless queen of the grave.
But what lends the grave such a lusture?
O'er her cheeks what beauty had shed?
His life blood, who bent there, had nurs'd her,
The living was food for the dead!

That is the account, as vague as it may be. It is an eerie recanting of the writer's presumably eyewitness report of a family's desperate attempt to effect a cure for consumption. In this case, we find that the cure was to turn the body facedown in the coffin. A small clue such as that might help in narrowing down the origins of some of the families who settled in the area at the time. Ancient Celts were known for this type of burial to make sure that the body rested in peace. They may also have performed this form of burial in order to confuse what they thought was a vampire. By burying the body facedown, it cannot find its way to the surface and instead may be inclined to dig deeper into the earth.

Arlene's first reaction upon hearing this method of exorcism was: "They did not think that vampires were very smart did they?" She half humorously commented on such precautions, stating that if a vampire has the power to rise from the grave, how would he be so obtuse as to fall for such a trick? It is a case that exemplifies how the living were often desperate and let their rationality fall to the wayside when dealing with their fear of vampires.

1810

BARNSTEAD, NEW HAMPSHIRE

Twenty-one-year-old Janey Dennit died of consumption and was buried in the family graveyard. When her father took ill, neighbors were compelled to dig her up and examine her for any strange sign that might prove supernatural forces were preying on the Dennit family. On September 5, 1810, the procession of family and friends gathered at the cemetery as soon as the sun rose. They exhumed Janey's body, which had been buried for a little over two years. Oddly enough, they were not looking for fresh blood on her lips or in her heart, or even a youthful rosy complexion upon her cheeks. Their interest was more in what might be protruding from the remains of her stomach. It was believed by these townsfolk, just like in Willington, Connecticut, and Dummerston, Vermont, that if vines or sprouts were growing out of her stomach or vitals, then surely an evil had taken up residence in her corpse and therefore had to be exorcised in order to save her father from the same fate. A traveling minister named Enoch Hayes Place, who wrote the account in his journal, witnessed this gruesome rite. He also made no secret of how it affected him to behold such a ghastly exhumation and examination of the dead woman's body, which consisted of little more than bones and the remains of vitals. He later gave a sermon in a neighboring town, where the people told him of another such exhumation that took place in nearby Loudon.

The Shakers had removed from the grave one of their own, presumably for the same purpose as in the Dennit account. When they examined the remains, they found eleven sprouts that had grown out of the bones, especially from the torso, and one that grew from the skull. It was reported that the

people who broke off the sprouts all died within a short time, and the cure was ineffective to the inflicted relative. Even the Shakers were convinced that something beyond the grave could be a threat to their well-being. Where does the notion that plant growth on the bones of the deceased is an evil omen or portent of death to another member of the family come from? Voltaire mentions that vampires often sucked blood from the stomachs of their victims. New Hampshire adopted this belief for its own set of criteria for vampirism. It is interesting to look at the different regions of New England and read about the different beliefs that prevailed in finding evidence of the living dead. Of course, this is closely related to the vine growing from coffin to coffin, as in the Burton case, but it takes things right to the body itself as host to the malevolent malady.

Either way, it's clear that there was widespread fear of the dead coming back to feed on the living. Unfortunately, there is no writing from the people who performed these exorcisms outlining their psychological reasoning or how the belief came into practice.

1817

WOODSTOCK, VERMONT

The case of Frederick Ransom was written by his brother, Daniel, in his unpublished manuscript, "Memoirs of Daniel Ransom." Although the script was written many years after the incident, when Daniel was in his eighties, it still brings home the dilemma that New England people faced in regard to the evil disease consumption. The incident took place in 1817, based on the recollections of Daniel. It is a classic example of how families turned to folklore and superstition in a desperate attempt to stop the dreaded affliction that was taking their loved ones to the grave.

Many notable figures have hailed from the bucolic Vermont town of Woodstock since its settlement in 1768, but it is also well known for its ghosts, peculiar monolithic structures and vampires. The Ransom memoir appeared about the time of Exeter, Rhode Island's Mercy Brown exhumation, having been acknowledged in 1894. About this time, articles and stories were popping up in just about every publication, from small-town papers to major scientific journals. It appears that the New England vampire had finally sunken its teeth into the annals of history.

Frederick Ransom, a twenty-year-old Dartmouth College student born on June 16, 1797, died of consumption on February 14, 1817. Frederick's father began to fear that his son might rise from the grave and begin to feed on the rest of the family, thus taking them to their graves. He therefore sought to have Frederick exhumed and his heart cut from his body and burned in order to save the family from imminent death. Daniel was only three years old at the time of the incident but recollected the eerie event with strikingly vivid detail.

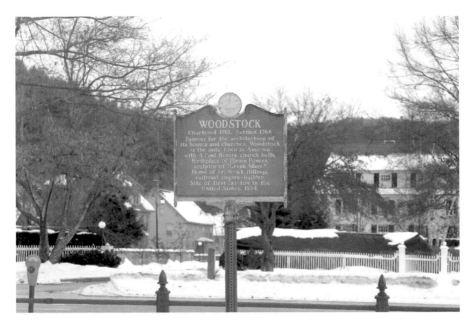

The quaint little Woodstock Green in Woodstock, Vermont, where a vampire exorcism was said to have taken place, twice. *Photo courtesy of Victoria Julian.*

The family was told that consumption, the early name for tuberculosis, was hereditary in the Ransom family. As stated before, many doctors and researchers believed that the disease was hereditary and not a contagious affliction. Even young Daniel was told that he would never see old age, as the white plague would take him to the grave before his thirtieth birthday. Daniel's father, being perhaps a bit desperate and superstitious, ordered Frederick's body to be exhumed and his heart to burned at Captain Pearson's blacksmith forge. The cure, however, failed to work; Mrs. Ransom died in 1821, followed by a daughter in 1828 and two sons in 1830 and 1832. Once again, we see the blacksmith forge being used as part of the ceremony for the exorcism of the evil that was upon them. Mothers used to pass their sick babies over the forge of a blacksmith in hopes that its magical powers would cure the toddler's ailments. Some went as far as having the blacksmith tap the child, who was laid upon the anvil, three times in the afflicted area with his hammer.

The Ransom account was published in the *Vermont Standard* in the 1890s. The manuscript resides in the Williams Public Library on Woodstock Green. For the rest of the century, families would use the same grisly method in hopes that this remedial effort might put an end to the infirmity that

was ravaging New England households. Perhaps this is why Mr. Ransom decided to write his recollections at the time he did. By then, exhumation was a somewhat common occurrence in New England. Rider's *Book Notes*, Stetson's "Animistic Vampire" and the pamphlet on consumption and its causes in New England by Dr. Henry Bowditch (see chapter on Saco, Maine) undoubtedly received some press. Coupled with the many other articles from reporters and newspapers, it seems that it was almost in vogue to write of vampirism, which was, years before, a shunned topic.

1827

FOSTER, RHODE ISLAND

Nancy Young, the oldest daughter of Levi and Annie Perkins Young, died of consumption on April 6, 1827. Her sister, Almira, soon became ill and began a rapid decline in health. Other family members began to wane in the same manner. Friends and family were convinced that something supernatural was at play. While searching through some records of Foster, Rhode Island haunts (namely the Ramtail Factory), I came upon a curious entry in the Foster Public Library. The following text comes from the Foster town records, as entered on October 14, 1892, under the title, "Interesting Notes Of Foster In 1827—Capt. Young's Purchase" It was notated, "The *Gleaner* today presents its readers with the fourth paper on the reminiscences of Foster, as originally published." Library director Kris Chin was familiar with the old document, reprinted here in its entirety.

Sixty years ago or more Capt. Levi Young of Sterling, Conn., who married Annie Perkins, bought the extreme southern portion of the original "Dorrance purchase" and erected a house thereon which is now the southwestern corner house in the town of Foster and commenced life as a farmer. His oldest daughter, Nancy, a very bright and intelligent girl, at an early age became feeble in health and died of consumption on April 6, 1827, aged 19 years. Previous to the death of Nancy, the second daughter, Almira, a very sprightly girl, commenced a rapid decline in health with sure indications that she must soon follow her sister. The best skill of the most eminent physicians seemed to be all in vain. There was a large family of children and several of them were declining in the same manner. Mr. Young was a

very worthy and pious man and wished to do everything possible to benefit his family, and he had the sympathy of all his friends and neighbors.

The installment goes on to tell of the actions the family and friends took to relieve the Youngs from their plight:

There seemed to be a curious idea prevailing at the time in some localities, that by cremating or burning the remains of a departed friend or relative while the living relatives stood around and inhaled the smoke from the burning remains, that it would eradicate the disease from the systems of the living and restore them to health.

A short time after the decease of Nancy, in the summer of 1827, the neighbors and friends at Mr. Young's request came together and exhumed the remains of Nancy, and had her body burned, while all the members of the family gathered around and inhaled the smoke from the burning remains, feeling confident, no doubt, that it would restore them to health and prevent any more of them falling a prey to that dread disease, consumption.

But it would seem that it was no benefit to them, as Almira died August 19, 1828, aged 17 years. Olney, a son, died December 12, 1834, aged 29 years. Huldah died August 26, 1836, aged 23 years. Caleb died May 8, 1843, aged 20 years. Hiram died February 17, 1854, aged 35 years. Two other sons lived to be older but are now dead. The youngest daughter Sarah is the only one now living of the family. She seems as yet to have escaped the disease of consumption. Some scientific persons thought perhaps the water in the well contained impurities which caused the disease as the whole family were of exemplary habits and very much respected; but it seems to have not been so, as no disease of that kind has visited the people who have since occupied the same premises.

Possibly this is the only instance of cremation in Rhode Island for the purpose of curing or preventing disease.

Sarah is now dead but lived many years after removing from the old place.

Dwight R. Jencks now owns and occupies the farm and has done so for years with a healthy family and no death in the house to the knowledge of the writer since the Young's family passed away. &c.

This is the only known case where the family actually stood around inhaling smoke as a cure. The writer at the time was either referring to the uniqueness of the exorcism or was not aware of the cases that took

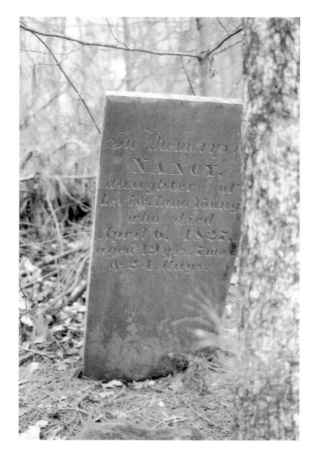

The gravestone of Nancy Young of Foster, Rhode Island, who died in 1827 and was dug up and burned while the family stood around inhaling the smoke in hopes that it would cure their affliction.

place several years earlier. In the earlier incidents, we saw the heart, liver and lungs being removed and burned. We also began to see an emerging pattern: the Rhode Island vampire was, perhaps by mere coincidence, being characterized as a young woman between eighteen and twenty-two years of age. This is a pattern that would persist through the rest of the nineteenth century. Also, as one looks at the timeline of Young family deaths due to consumption, one notes that there is a twenty-seven-year span between the first death and the last. Many families lost several members in a much shorter span. It is no wonder many New Englanders turned to folklore and superstition to try and eradicate what medical doctors could not.

In regard to Rhode Island vampire cases, Mercy Brown and Nancy Young are the only two with legible grave markers (save for the Aldrich stone in North Smithfield). The rest are either fieldstones, missing or cannot be located for one reason or another. Arlene and I made several visits to the Young lot

and found that it is, as reported, on the Connecticut–Rhode Island line. Our friend Ron Kolek Jr. of the New England Ghost Project accompanied us for one of the treks to the far end of Foster. With permission from the owner of the land, we visited the small cemetery and looked at the gravestones, which were all of the same style. We began to try some EVP (electronic voice phenomena) recordings. The area was quiet, being mostly farmland off the beaten path, so we figured the tranquil setting might be the right combination for receiving a few answers from the other side. Could we actually get some answers about what happened so many years ago? What if we had firsthand information from those who were present in 1827? It may sound a bit far-fetched, but that is the purpose of EVP work, to get answers and information that helps in paranormal cases. Yes, we treated even the vampire cases with a bit of a paranormal edge. After all, there could still be lingering energy. Unfortunately, there were no voices captured on the recorder. We did, however, substantiate the dates and record the information we needed before heading off to the next stop on our exploration of Rhode Island vampires.

Anthony Dunne, a director at WGBY, took great interest in the New England vampire stories. He contacted me to help him with filming a

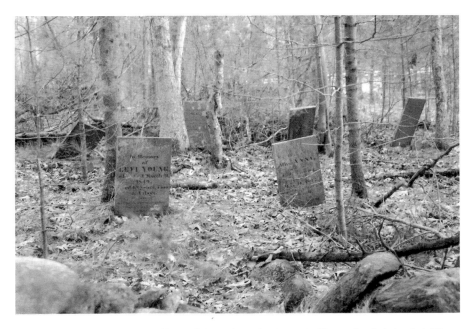

Historical Cemetery # 142 in Foster, Rhode Island, where the Young family is buried. The stones tilt in all directions. Note Levi and Anna in foreground.

television special on location at many of the region's places of legend and haunts, as I had already visited and written about them. During the filming of the award-winning 2009 WGBY documentary, *Things That Go Bump in the Night: Tales of Haunted New England*, we chose the Young lot as one of the places to film. As we approached the small cemetery, I noticed something different right away: the lot had been cleaned up. There were no more fallen branches or small trees strewn across the graves. The major brush had also been cleared away, and the stones that were hidden in the bramble were now easily accessible. One of the residents of the home adjacent to the cemetery came out to see what we were doing.

"Come to see the witch?" she asked.

"Actually, she was supposedly a vampire," I said quietly.

"Oh, that's right, she was a vampire. That's what I meant."

I did not want to speak too much or too loud; we were filming the cemetery, and less noise would make it easier to edit later. When we were done, the woman told us that she and her husband had cleaned up the cemetery, as it was looking rather neglected. It was then that I related to her the story of what had transpired in 1827.

Foster Historical Cemetery #142 sits on the border of Rhode Island and Connecticut, off Jenks Hill Road on private property. It is a rather interesting cemetery in both its location and appearance. It is very typical of the New England family burial lots common throughout the region. The stones are tilted from side to side or back and forth within the confines of the short stone wall of the burial ground.

In 1827, consumption was also being called the white plague and was viewed as a romantic disease by many. It was thought that the disease created a euphoric state of higher awareness in the afflicted person. If one suffered from a slow consumption, it was considered a kinder form of death, as the sufferer was able to put his affairs in order. Consumption became, to the wealthy, a form of spiritual enlightenment. Upper-class women actually began to make up their skin to look chalky and pale in order to achieve the corpselike hue of a consumptive victim. In 1828, Lord Byron stated that he would rather like to die from consumption, thus furthering the romantic notion of the disease by making it a disease of artists. It is doubtful that the rural folk of New England were sharing in this upper-class revelry and folly.

1830

WOODSTOCK, VERMONT

In 1830, another vampire exorcism was said to have taken place in Woodstock concerning a family named Corwin. Much like the other tales of New England's undead, a family member succumbed to consumption. Another member of the family, a brother, soon exhibited signs of the same disease. A certain Dr. Joseph Gallup was credited with telling the family that as long as there was the blood of the sick brother in the heart of the deceased, the terror would continue until the second Corwin was taken to the grave. This implied the work of a vampire. There was only one solution: cut out the heart of the evil demon and end the trepidation once and for all.

The deceased was exhumed from Nathan Cushing Cemetery in Woodstock as a crowd assembled on the green. It is written that most of the town showed up to witness the exorcism. A fire was cast on the green, and the heart of the exhumed brother was cut out and burned to ashes. The ashes were then put into a pot to be buried in a hole dug in the center of the village green. Some of the ashes were saved for use as medicine for the ailing Corwin.

The pot was put into the fifteen-foot-deep hole and covered with a seven-ton slab of granite. The townspeople sealed the hole in hopes of vanquishing the evil that had befallen the Corwin family. After the pot had been interred, the townspeople sprinkled the freshly turned earth with bull's blood. The dying brother was made to drink the mixture of ashes and bull's blood, along with some medicine, in order to cure his illness. Whether the cure worked is a mystery; so are the whereabouts of the Corwin family, the slab and the pot.

This account also appeared in Dr. Michael Bell's *Food for the Dead* and Christopher Rondina's *Vampire Hunter's Guide to New England,* although both have asserted that there is no evidence that this particular exorcism was ever performed. Records show no existence of a Corwin family interred at the Cushing Cemetery. Even the green has been excavated in search of the seven-ton slab of granite and pot of ashes. Nothing of the sort has ever been found. Could the facts have been diluted over time? Perhaps the names were misspelled or changed by accident. Maybe it was another town. Records show that a Dr. Gallup did reside within the town, but other than that, there are no written documents to prove that the macabre event ever took place. It appears to be one more mystery in the ever-elusive tale of the New England vampire.

1841

SMITHFIELD, RHODE ISLAND

Few, if any, residents of Smithfield, Rhode Island, are aware of the fact that there is a case concerning the word vampire buried within their town. But alas, they gave it away in 1871, when a portion of the town was divided into North Smithfield, Lincoln and Woonsocket. Just shy of the North Smithfield–Woonsocket border is the Union Cemetery Annex on Great Road. This burial ground includes several smaller graveyards along the eastern edge. Among those smaller lots, covered in brush and saplings, is the grave of Simon Whipple Aldrich. Simon was the youngest son of Colonel Dexter and Margery Aldrich. Simon died of consumption on May 6, 1841, at twenty-seven years of age.

While filming the 2009 award-winning documentary for WGBY, *Things That Go Bump in the Night: Tales of Haunted New England*, producer Anthony Dunne wanted to see for himself this special gravestone. Since I had been assisting him with the Rhode Island stories and some of the Massachusetts ones as well, I was more than happy to show him this piece of Rhode Island's history. We had already spent a whole day trekking through the Ocean State filming some of the more interesting places of legend and lore. He arrived with WGBY videographer Mark Langevin. Paranormal United Research Society member Kevin Fay accompanied me. As we exited our vehicles, I was excited about finding the Aldrich stone. I could now officially state that I had visited every known and identifiable vampire grave in Rhode Island. I already had Connecticut covered, and as for Vermont, well, Arlene and I at least found some of the Spaulding family graves and the lieutenant's stone. The ironic part of this visit was that it was the closest grave of "vampire

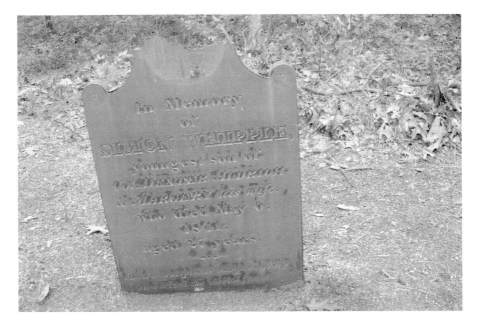

The stone of Simon Whipple Aldrich in North Smithfield. The first two lines on the bottom say it all.

interest" to where we lived. We had driven by the cemetery annex many times, yet Arlene and I had never ventured into the brush to pay a visit.

As soon as we were in the thicket, a small dilemma arose: there were numerous little plots scattered throughout the woods. Many of them were heavily covered with brush. After several minutes of searching, I called out to everyone to look for a site clear of brush and with the ground around it well worn, as many people surely would have visited that particular grave. No sooner had I finished that statement than Mark yelled, "Over here, I found it!"

We all headed in the direction of the grave. It was amusing to note that there was a well-worn path leading from the main cemetery annex right to the Aldrich stone—about as obvious as the roped-off teller lines at a bank.

I first heard about the grave several years ago during a meeting with Ray Dowaliby, founder and owner of *Scars* magazine. He had asked me to do a vampire article to promote the magazine and gave me some slim details on what he knew of the Aldrich story from a visit he once paid there. I looked up the cemetery and vital records to find out more about the family members and the grave that bore a rather strange inscription.

Simon Whipple Aldrich was one of several family members who died at a relatively young age. His older sister died shortly before him, and his younger sister died three years after. In fact, several of the children died within nineteen years of one another at fairly young ages. Polly, born in 1801, died on August 13, 1825; Patience, born in 1808, died on December 12, 1831; Anna, born in 1818, died on May 14, 1842; and Betsey, born in 1828, died on May 12, 1844. Although consumption might have been to blame, there is no record of any of the family being exhumed. The interesting aspect of this account is what is carved in Simon Whipple Aldrich's stone: "In Memory of Simon Whipple Youngest son of Col. Dexter Aldrich & Margery his wife who died May 6, 1841 aged 27 years." The inscription below reads: "Altho consumption's vampire grasp had seized thy mortal frame, ------------------- ing mind."

The bottom of the stone has been cemented into the base, covering the rest of the inscription, which may have consisted of two or more lines. But the upper portion is quite revealing. Did the Aldrich family believe a vampire was at work, or was this just a metaphorical way of saying that the dreaded disease was a microscopic vampire that sucked the life out of the living?

1847–1862

SACO, MAINE

Arlene's daughter, Mandy, and her fiancé, Justin, live in Biddeford, Maine. Saco is the adjoining town. The towns are so close together that there are some who refer to the area as Saco-Biddeford. Saco is a typical sleepy little eastern Maine town. It appears that once, while the residents slept, there were some who were reported to be roaming the night, sucking the life out of their loved ones.

In Dr. Michael Bell's *Food for the Dead*, there is mention of a series of exorcisms that took place in Saco between 1847 and 1862. Although there are no specific names, there are references to this fact in a pamphlet by Dr. Henry Ingersoll Bowditch (1808–1892). Taking Mr. Bell's lead, I decided to look up the writing myself. The pamphlet *Consumption in New England: Or Locality One of Its Chief Causes. An Address Delivered before the Massachusetts Medical Society* outlines vaguely the cases of consumption and their treatment.

> *Dr. Allen of Saco, Maine, than whom there lives no more intelligent witness—a practitioner of long standing—assures me that, in his own practice, for fifteen years past, he has noticed that on two ridges of land, whose only difference consists of this characteristic of moisture of the soil, almost every family has been decimated on the wet part, while almost all upon the dry portion have escaped.*

He goes on to describe the surrounding area and then adds, "In fact, in former times, the superstitious frequently had their friends, who died of consumption, disinterred…"

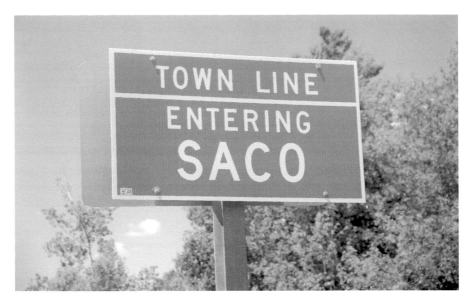

Entering Saco, Maine, where exhumations for vampirism were once reported to have taken place.

Bowditch also explains, in depth, how the wet and damp locales of New England were rife with the dreaded disease. He cites statistical data to back up his theory that consumption was much more prevalent in these damp areas. He also had doctors and specialists from various places throughout New England back up his findings. He mentions that a Dr. Trafton of Kennebunkport, Maine, substantiated that consumption cases occurred in greater numbers near the port, where the soil and coastal exposure created damp conditions. Kennebunk, with its wooded land, higher elevation, drier climate and fewer open areas, was in contrast to the port region. Consumption was found in a much lesser degree in places where the climate was drier.

Bowditch, through his research and experiments, came to a few conclusions about the disease. One was that consumption was not equally distributed across the region. Another was that the amount of cases from one area to another depended on the soil near where the patients resided. He also concluded that the moisture within the soil gave rise to consumption.

Through his research and conclusions, Bowditch believed he better understood the causes, treatments and preventative measures pertaining to consumption. Many of his colleagues supported his belief. However, the disease still raged across the region regardless of terrain or climate. (An interesting note is that Bowditch was chairperson for the Massachusetts

State Board of Health, as well as president of the American Medical Association. He published a few writings on inductive reasoning in medicine and concepts of state and public health. His work would have been highly regarded by his peers.)

Arlene and I decided to take a trip up to Saco and see what we could find. The first place to look would be a cemetery. If most of these incidents took place in the fifteen-year period between 1847 and 1862, chances are, the deceased would have family plots in a garden cemetery. Garden cemeteries—large, landscaped burial grounds—became popular in the early nineteenth century. The first chartered burial ground in the United States is reported to be the Grove Street Burial Ground, established in New Haven, Connecticut, and incorporated in October 1797. It is also hailed as the first nonprofit private burial ground in the world. The planned layout, family-owned plots and carefully landscaped flora and trees were something no one really saw in this country until the Mount Auburn Cemetery opened in Cambridge in 1831.

Sure enough, Mandy and Justin knew where the only cemetery of such caliber was in Saco. We soon came upon the Laurel Hill Cemetery, a well-groomed, large burial ground with little bridges crossing a stream and twisting

Laurel Hill Cemetery in Saco, Maine. There are several plots in this cemetery of family members who died very close together.

little lanes much akin to older cemeteries. Mandy's four-wheel drive Tracker was perfect for the time of year, January, when the roads were barely plowed if at all. We snaked through the cemetery, sometimes ramming through the snow banks left behind by the plows. Our main goal was to find stones and plots from that period (1847–1862) of family members who may have died in close succession. A subsequent visit in July enabled us to explore further, as the roads were clear. Sure enough, there were plots where the dates on the stones were from the same year or very close. While this, of course, is not proof that consumption was the cause or that these were the families Dr. Bowditch referred to in his paper, it certainly points to that possibility.

The actual names of the families about whom Dr. Bowditch and Dr. Allen speak remain a matter of conjecture. With no actual writing in stone, it is hard to tell if consumption was the actual cause of death or if these people were claimed by one of the many other diseases that plagued New England during the time.

1854

JEWETT CITY, CONNECTICUT

Vampires and New England go hand in hand. It seems that these creatures that were thought to roam the dark corners of humankind's domain made a special home in the rustic little hamlets of the region. Although Rhode Island may claim to be the vampire capital of America, just over the border of the Ocean State were a few very famous accounts pertaining to the creatures of the night.

The grotesque details of the next few paragraphs are sure to make you shudder. Jewett City, a small village in the town of Griswold, is the next destination for this most bizarre narrative.

Griswold is the perfect little New England town. Farms dot the landscape, and historic homes lace the one-lane scenic thoroughfares. One would not expect its boundaries to be infected with the devil's concubine, but at one time, people thought exactly that, and measures were taken to banish the evil they feared roamed among them.

Consumption had no boundaries, and even in this little Connecticut hamlet, it was a major fear of all families in the eighteenth and nineteenth centuries. Once one member of the family caught the illness, the rest would embrace, with terror, the thought that they, too, could soon become infected. Many New England families lost numerous members to consumption. The afflicted wasted away as if something was feeding off their very life force, and surely, something was. Many turned to folklore and superstition in an attempt to remedy their plight. Scores of families began digging up their loved ones for fear that one of them may be returning in the dark of night to take them all to the grave.

The graves of Henry B., Lucy H., Lemuel B. and Elisha H. Ray in the Jewett City Cemetery. Lemuel and Elisha both died of consumption. One was thought to be a spectral ghoul preying on the family until the suspect was reportedly disinterred and burned in 1854 to save another brother from the same fate.

Consumption struck the Ray family of Jewett City. Lemuel Billings Ray died from the dreaded illness on March 9, 1845, at the age of twenty-four. His father, Henry B. Ray, followed him to the grave on July 3, 1849. Soon after, twenty-six-year-old Elisha Ray fell victim to the wasting disease and died on February 1, 1851. It was not until Henry Nelson Ray became ill in 1854 that the family began to wonder if something supernatural was at work. The family was desperate to end the chain of sickness that had taken several of them already. They came to the conclusion that their plight was the work of a vampire among them, but who?

According to *Mysteries and Legends: New England* by Diana Ross McCain, the bodies of all three deceased were disinterred, and Elisha, having been the most recent to die, was the only one who had not yet completely gone back to the earth. In fact, according to McCain's research, as reported in 1854 by one of the newspapers, the heart of Elisha contained "fresh blood," thus securing the family's belief that a vampire was at work. They burned Elisha, coffin and all, before becoming wholly satisfied that they had performed a successful remedy.

The *Norwich Evening Courier* also covered the story of the exhumation, calling it a "strange and almost incredible superstition." The account goes on to state that the family's determination to exhume the bodies and burn them was "because the dead were supposed to feed upon the living, and that so long as the dead body in the grave remained in a state of decomposition, either wholly or in part, the surviving members of the family must continue to furnish the sustenance on which the dead body fed." There is no mention of vampirism at this point, only an unbelievable superstition, which, in the words of the article, "tasks human credulity." It also mentions that the scene, as described to reporters, was repulsive to say the least. The article finishes with the following conclusion: "We seem to be transported back to the darkest age of unreasoning ignorance and blind superstition instead of living in the 19th century, and in a state calling itself enlightened and Christian."

I procured a copy of the article and can confirm that it does seem to capture the attention of the reader in a most macabre and shocking manner.

According to the timeline of mortality etched into Henry's stone, the cure failed, as Henry N. Ray died in 1854 at the age of thirty-four. Three of Henry's children and his wife also succumbed to mysterious deaths that left people wondering if a vampire was still at work within the Ray family.

The rest of the Ray family was buried behind the post office in the center of town before being relocated to the Jewett City Cemetery in the early twentieth century.

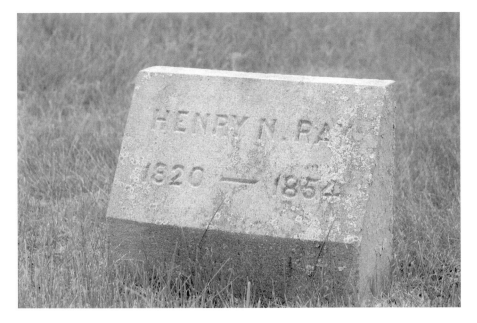

The marker of Henry N. Ray, who died in 1854, despite the exorcism performed to save his life.

I contacted Griswold historian Mary Deveau, who knew of the two brothers being disinterred but not the father. She was aware of the *Norwich Evening Courier* newspaper clipping dating back to May 20, 1854, which told of the account that took place on May 8, 1854. She told me what she knew based on the historical data she had collected in regard to the incident. According to the *Courier* article, the two brothers were dug up, but no mention was made of the father being disinterred. Having dug up both brothers, the family then burned both bodies on the spot in hopes of relieving poor Henry N. of the evil that was taking him slowly to the grave. The *Courier* mentions that the father was Horace Ray, not Henry, but it does offer a disclaimer in the beginning that the story was related to a reporter who may not have been on the scene.

Which article is more accurate? Does it really matter? The details may vary a little, but the date and end result pretty much coincide with each other. Mary had the copy of the Norwich article but was not aware of the other report. She has a lot of files on the vampires of Griswold, yet there is so much more to be found out about the incidents, especially considering the coverage of the exorcism became so widespread.

Arlene and I ventured out to the Jewett City Cemetery to find the graves of the Ray family. Upon entering the large iron gates, the Ray monument

sits to the left, just inside the cemetery. We found Henry N. and a few other names, but no Elisha. We even found a Lemuel, but the date of death was long after the alleged incident of suspected vampirism. There had to be other graves elsewhere, so we began our search. Arlene took one side, and I took the other. After a short time, we came across the other Ray family in the center rows of the cemetery, to the left of the gates, looking out. The four graves of Henry B., Lucy H., Lemuel B. and Elisha H. were certainly in vogue with the times; yet the other Ray plot was much more modern, having a large monument stone with smaller, plain granite stones surrounding the main obelisk.

Although the death of Henry N. occurred in the same era as the others, the stones were, in contrast, more modern. My first thoughts were that perhaps Henry Nelson Ray was a relative and that the newer plot was that of a family related in some way to Ray. Was he a cousin or a nephew? According to Dr. Bell's research, some of the Ray family graves were moved in the early 1900s. Maybe a surviving member of Henry Nelson's family wanted to expand the plot for future generations and had more modern stones put in. This would explain why the rest of the graves were not moved. A grandson of Henry N. might have moved his immediate family but not his grandfather and uncles. This is interesting speculation when trying to figure out why the graves are so different in nature yet the dates of death so close to one another. The newer stones are twentieth century without a doubt, and the other Ray stones are typical nineteenth-century tall slabs.

I again called Mary Deveau of the Griswold Historical Society, and she was more than happy to share her knowledge of the Ray family with me. Henry N. Ray and his family were first buried in the cemetery behind the Baptist church on Main Street, next to the post office. The church did not own the cemetery; rather, it was privately owned by a member of the church. The Ray family, being part of the congregation, was buried there. For some reason or another, their bodies were moved to the Jewett City Cemetery. Deveau does not know what happened to the original stones but commented on the fact that she was curious about what became of them after the family was relocated.

We speculated back and forth about why they would have been exhumed and relocated. She could not find the exact date the graves were relocated but was sure it was in the early twentieth century. We both agreed that a family member had to have had the graves moved in order to be closer to the original Ray plot. Henry was the third son of Henry Baker and Lucy Ray. Henry N. had four children who died during their infancy, some at

childbirth and some very shortly after. One of his daughters, Nettie, lived to the age of twenty-six before dying of consumption. My theory was at least half right: a family member had the graves relocated. On the other hand, Henry was the brother of Elisha and Lemuel and not a relative otherwise. There was another brother of Henry—Charles, who is also buried in the newer plot. It may have been Henry Nelson's wife, Clarinda, who had the family moved, as she died in 1902, or maybe it was Charles and his wife, who were buried in the newer plot much later. The newest stones belong to Charles Ray, born in 1842, and his wife, Sarah, born in 1846, who both passed away in the same year, 1927.

About this time, a tuberculosis patient named Herman Brehman believed the disease was curable. He retreated to a healthier mountain climate and came back cured. This prompted him to establish the first tuberculosis sanatorium, where patients got the help they needed in a climate that was effective in curing the illness. It worked to some degree, but a cure was still being sought.

1874

SOUTH KINGSTOWN EXETER. RHODE ISLAND

It is written that in 1874, William Rose of Peace Dale exhumed the body of his recently deceased daughter in order to avoid any possible threat that she might come back and feed on the rest of the family. Records state that he burned her heart in order to thwart such an inevitable future calamity. This elucidates the fact that Mr. Rose was more than aware of the practice of exorcising those who had died of consumption in order to bring to a halt a case of vampirism. Instead of waiting for other family members to begin showing signs of the wasting disease, he took it upon himself to nip the situation in the bud before it became an epidemic.

The short commentary that has appeared in magazines, newspapers and books also states that the graves of William and his wife, Mary, reside in the Rose Hill Cemetery just off Route 138, but the daughter's grave is nowhere to be found. When I first read the small quip in the October 1992 *Old Rhode Island* magazine, I became intrigued and intent on finding the missing grave.

Ruth Ellen Rose (or Juliet Rose) by all accounts died in 1874 at the age of fifteen. In typical Rhode Island fashion, the young woman was exhumed, and her heart and vitals were cut out and burned because her family feared that she was a vampire. What was different about this case was that, according to the article, William Rose performed the exhumation to avoid the *possibility* of vampirism—not to stop an existing case. But why can't we find the Ruth Ellen's grave? That was the first question Arlene and I pondered upon reading this narrative. Now it was time to try to piece together a mystery that seems to have baffled every other researcher of the New England vampire.

I studied a map of South Kingstown, particularly the area of Mooresfield Road where the Rose lot, SK-010, is located. There were several cemeteries in the area that we would visit looking for any clue of Ruth Ellen/Juliet Rose. Of course, SK-010 would be our first stop.

The Rose lot sits fifteen feet north of Mooresfield Road on Rose Hill Road at telephone pole #4418. The 125- by 140-foot burial ground contains 122 burials, with 122 inscriptions dating from 1851 to 1972. That certainly falls into the time frame of the daughter's interment. There is a special note in the cemetery records by James Arnold, dating back to 1880, stating that the burial ground was a large, beautiful yard with a cut stone wall containing many metal rings mounted on the front wall for tying up horses. The graves of William C. and Mary A. sat prominently at the entrance of the cemetery, just inside the gates. Arlene and I closely inspected the yard for signs of missing, fallen or broken stones. There was no sign that a stone with the name Juliet or Ruth Ellen ever existed. There is a hand-painted sign in front of the wall that reads, "Please Stop Stealing Stones!" But it does not make clear whether it was the gravestones or the beautifully cut wall stones that were victims of theft. We figured that while we were in the area, we might as well check out the other small cemeteries as well. One by one, Arlene and I began to pick out and visit each historical cemetery in the area. There were several within a few miles of one another. Some were in obscure places, while others were in backyards, at the edge of driveways or in the middle of the woods.

SK-011 was where Juliet Rose had supposedly been interred. The cemetery is located fifty feet west of Broad Rock Road in South Kingstown. Some stories say that Juliet was the "vampire" that plagued the family. Juliet Carter Rose was born in 1814 and died in 1898. She lived to be eighty-four years of age, leaving Ruth Ellen as the only other possibility.

As the sun began to quit the horizon, it was time for us to suspend our search for the elusive Ruth Ellen. We headed home, somewhat disappointed and satisfied at the same time. We had scoured a good amount of cemeteries and found that there was no Ruth Ellen. This would prove valuable for others who wished to search for the same grave. At this point, I decided to try a new approach to the situation. The article stated that the event took place in Peace Dale, a small village about five miles from the Rose lot. I cannot say how many times I had heard it said that people in the old days never ventured more than five miles from their homes. If so, then why would they be buried so far away?

I looked up the cemeteries in Peace Dale and found the Oakdell Cemetery. From there, I began to search for a Rose lot. While scrolling through the

names, looking mostly at the dates, I found it: May 12, 1874. The name, however, was Phebe Rose, who died on May 12, 1874, at the age of forty-eight years. This created even more confusion. How were they related? Was Phebe a relative? Did the writer of the original article have some misinformation or a combination of a few accounts that were rolled into one story? Why fifteen years old? Who was Ruth Ellen? These were just a few of the questions that began swirling in my head.

One more possibility was that the name might have been misspelled along the way. I decided to check any name that was close to the spelling of Rose. Starting with Ross, I began to scroll down, looking at dates. A few minutes later, I hit a date: May 12, 1871. The name of the person was Ruth Ellen. The only snag to this lead was that, although Ruth Ellen Ross died on May 12, 1871, at the age of—you guessed it—fifteen, the cemetery was CH-045 in Charlestown, Rhode Island. How did all this add up? Why was Ruth Ellen buried in a completely different cemetery from the rest of her family? To add a little more spice to the pot, there is also a Ruth S. Rose buried in WK-034, but there are no dates given for her birth or death.

Taking all of these names into consideration, as well as the fact that the cemeteries are all in South County, there has to be some sort of connection between them. A few rational explanations might clear up the confusion. It was common in the eighteenth and nineteenth centuries for people to make errors in recording records. Doctors would ride out to homes and record the death of a family member, perhaps take in a few drams of rum as partial compensation and then ride off to another patient or journey home. When they were able, they would venture to the town halls or capital city to file records. Sometimes that took a while, and names would pile up. Perhaps they got a few mixed up and did the best they could to remember who was who when writing them down; sometimes they lost the information and had to go by memory. That does not mean that all of them were wrong or mislabeled, but mistakes or misspellings were not uncommon in those times. Also, as we look at the modern compilations of cemetery records, we see many names. In 1874, many of those names were not there. The data we use for research has been painstakingly compiled for historical record. At one time, there could have been an entry somewhere where Rose and Ross were right next to each other. This could easily cause a researcher and writer to possibly mix up the two inadvertently. Stories handed down by word of mouth tended to take on a lot of inconsistencies or became embellished for the teller's sake. Some of these inconsistencies, as stated before, might be due to misspelling, errors in recording or even lack of recording, or maybe the

authors and subsequent writers around the end of the nineteenth century figured that the Rhode Island vampire had to fit the previous cases of being a fifteen- to twenty-two-year-old female. This would cause the first writers of these cases to manipulate the facts, possibly thinking that the records were, as was often the case, recorded incorrectly. In this case, what they thought they were fixing was actually becoming a whole new dilemma for historians and modern-day researchers to try to puzzle out.

Of course, there is a common thread: Abigail Staples, Sarah Tillinghast and Nancy Young were all young women between fifteen and twenty-two years of age. Ruth Ellen and, eighteen years later, Mercy Brown would also fit the bill. Taking this into perspective, it is easy to suspect that someone shuffled around the records to suit their needs. Remember that this is only a theory; no one remains to divulge the source of the article's information. Much of the accounts were passed down in families by oral tradition, so it is easy to have several cases mingled into one.

Arlene and I did find the Rose lot in Oakdell Cemetery. There are over eighteen hundred burials, but we got lucky after searching for about twenty

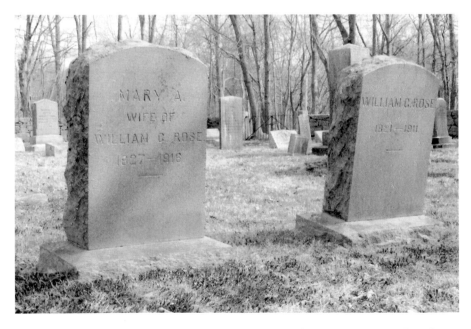

William C. Rose and Mary A. (Tillinghast) Rose rest peacefully at the entrance of the Rose Hill lot, South Kingstown Historical Cemetery # 010. Mary's great-grandfather was Stutley Tillinghast.

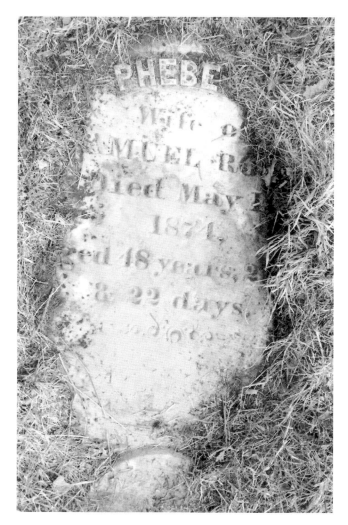

The grave of Phebe Rose in Oakdell Cemetery in Peace Dale coincides with everything the 1874 article describes, except the age she was supposed to have been when she passed.

minutes. A single monument marks the plot, as the other stones have fallen over and are partially covered by grass. The cemetery is closely watched by authorities due to previous vandalism, so please be respectful and visit only during the hours posted.

It was Dr. Bell's research that provided me with what I feel is among the most compelling evidence that the vampire theory was handed down from generation to generation. William C. Rose married Mary A. Tillinghast, granddaughter of Amos Tillinghast, who was the son of Stutley and Honor Tillinghast. This was a very important piece of information as it provides a direct reason for why Mr. Rose may have been hasty in making sure the rest

of his family would not suffer from the spread of consumption, or at least it was written into the account by early researchers who found the same marriage record. The oral tradition of Sarah Tillinghast surely had to have been passed down to Mary. Many thanks go out to Dr. Bell for this piece of information on family lineage and the connection between these two documented cases.

It is interesting to note that several years later, on March 24, 1882, Dr. Robert Koch (1843–1910) of Germany revealed to the Physiological Society of Berlin that the disease was indeed a microscopic infectious agent by isolating the germ with a staining agent he had experimented with on other diseases and bacterium. The world now knew that tuberculosis bacillus was, without a doubt, the primary cause of the wasting sickness. This is why March 24 is known as World Tuberculosis Day and has been since 1982, one hundred years after Dr. Koch astounded and enlightened the world with his discovery.

1870s

WEST STAFFORD, CONNECTICUT

In the *History of Tolland County, Connecticut*, written in 1888, J.R. Cole describes an exhumation based on an unusual superstition that the people of West Stafford were inclined to believe. Dr. Michael Bell faithfully retells the report in his 2001 book, *Food for the Dead*. According to the account, there were six sisters, and five of them died in rapid succession from galloping consumption, a fast-moving form of the disease. In order to save the sixth sister, the people of the town adhered to a strange notion: "The old superstition in such cases is that the vital organs of the dead still retain a flicker of vitality and by some strange process absorb the vital forces of the living."

They had heard of instances where the heart and lungs had stayed healthy while the rest of the body decomposed. These organs, upon burning, would cause the living relative to recover from his illness. A strange twist is added here, however: the deed must be carried out by a lone adventurer, and only at night, for the cure to have an effect. Again, the word "vampire" is not mentioned, but the word "superstition" seems to show up regularly in contemporary writings. As for the outcome of this narrative, it remains a matter of conjecture, as nothing further is said about what may have transpired in an attempt to cure the final sister.

1889

WEST GREENWICH, RHODE ISLAND

I am waiting and watching for you.

In a horror movie or suspense thriller, the above saying might have a more fearful, ominous or foreboding tone, but etched into a nineteenth-century gravestone, it means that the loved one is waiting to either reunite with family members in heaven or lying in wait for the coming of the Lord. Unfortunately, to some it was a sign that a spectral ghoul resided beneath, and so a legend was born.

Believe it or not, one of the most famous Rhode Island vampires was never disinterred, or even suspected of vampirism, although she was exhumed from the family burial lot and reinterred in the public cemetery at the corner of Plain and Liberty Hill Road on October 26, 1889, when the family sold their farm. Other than that, she remained anonymous; that is, until a group of legend-trippers stumbled upon her grave in the 1960s.

Nellie Louise Vaughn died on March 31, 1889, at the age of nineteen, presumably of pneumonia, not consumption. She was first buried in the family lot on her farm. Small, private family plots were very common in Rhode Island and, in some cases, are still in use to this day. Families who have owned the same land for centuries have their own private cemeteries where they can someday be buried with their ancestors.

The legend was born when, as the story goes, a Coventry teacher told his or her students about the vampire grave, just off Route 102 in South County, of a nineteen-year-old girl who died in the late 1800s. The teacher never gave a name or exact location. It can be assumed that this particular teacher

was referring to Mercy Brown but could not remember, or did not know, the girl's name. Either way, a group of classmates gathered together one night to find the grave of the vampire. How they came upon the historical cemetery behind the Plain Meetinghouse is another matter of mystery. Perhaps they had an atlas with the cemeteries marked and began a tour of each one, looking for telltale signs of a *nosferatu*, or maybe one of the legend-trippers already knew of the graveyard.

It did not take long for the seekers of the unknown to find what convinced them that their search was over. Just inside the cemetery sat Nellie's stone with the now-famous inscription. Nellie's age at the time of death and the date of her death closely matched the teacher's description, and another Rhode Island vampire was born.

Since then, countless people have paid a visit to the graveyard looking for the grave site where, as legend states, no moss, lichen or grass will grow. It was also related that the grave continues to sink into the earth. There is no stone marking her plot, as it has been removed and stored away in an undisclosed location for preservation. Nellie's grave site appears to be well tended with grass and is not sinking, as legend has proclaimed. There are a few areas in the burial yard where people claim she is buried, and all of

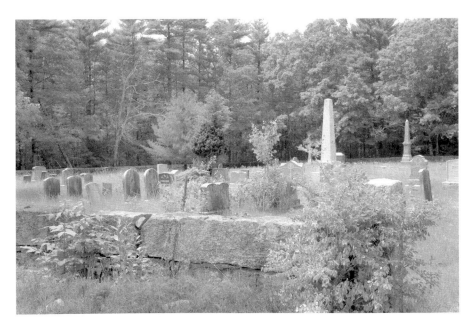

West Greenwich Historical Cemetery #2, where the "mistaken" vampire, Nellie Vaughn, is buried.

them, for the most part, have plenty of vegetation on them. Unfortunately, the cemetery has been subject to much vandalism—so much so that there is a neighborhood watch, as well as police patrols on a regular basis.

There were also claims by certain paranormal groups that Nellie was buried alive, but no evidence to substantiate that assertion has ever been produced. Neither has there ever been any evidence that she may have been accused of vampirism during her time. Another recent aspect of the Nellie Vaughn saga involves the alleged sighting of a young woman in the graveyard and an ethereal voice emanating from nowhere saying, "I am perfectly pleasant." In the book *New England Ghost Files*, Charles T. Robinson states that people have heard the words echo through the air while in the cemetery and have spotted the visage of a young woman near the grave of Nellie Vaughn.

Acclaimed author and paranormal investigator Christopher Balzano once stated that we have a tendency to immediately blame a haunting on the most famous person who lived in or passed through the area. Unfortunately, there is no indubitable evidence on the paranormal side to support that, even if there is a voice calling out to the visitors, it is actually Nellie's. We already know she was never accused of being one of the spectral visitors blamed for sucking the life from family members in the eighteenth and nineteenth centuries. If anything, there is a beautiful historical cemetery and meetinghouse that should be left alone and respected. There is no need to waste your time traveling four miles up a winding road to see, well, nothing.

If you decide to visit the cemetery, please respect all rules and regulations regarding the cemetery and the historical meetinghouse.

1892

EXETER, RHODE ISLAND

EXHUMED THE BODIES—TESTING A HORRIBLE SUPERSTITION IN THE TOWN OF EXETER—BODIES OF DEAD RELATIVES TAKEN FROM THEIR GRAVE. They had all died of consumption and the belief was that live flesh and blood would be found that fed upon the bodies of the living.

That was the headline in the *Providence Journal* on March 19, 1892. The story tells of the gruesome account in which three of the Brown family were tested for vampirism. Related here is the story of the most famous case of alleged vampirism in New England, if not the world.

Mary Eliza Brown, wife of George Brown, died of consumption on December 8, 1883, at the age of thirty-six. About six months later, on June 6, 1884, their daughter, Mary Olive, succumbed to the disease at the age of twenty. Several years later, Edwin Brown became ill and, on the advice of his friends, removed himself to Colorado Springs with his wife, Hortense. During his absence, a sister, Mercy Lena Brown, became ill with galloping consumption, a fast form of the disease, and died within a few months of contraction. Upon Edwin's return, he also contracted consumption, and his health began to decline rapidly.

Friends and neighbors feared that in some way, one of the relatives of Edwin was feeding upon his flesh and blood, causing him to waste away. The rest of the article tells the story of the exhumation. Although other such exhumations had taken place, it seemed outrageous from a medical standpoint not to mention that many people thought it was an antiquated, gruesome method of curing the malady. Needless to say, the exhumation

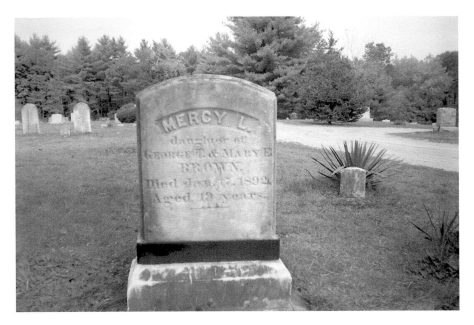

Mercy Brown's stone in the Exeter Historical Cemetery #22 on Chestnut Hill, once called Shrub Hill.

The Brown family plot: father, George T.; mother, Mary E.; two daughters, Mary Olive and Mercy Lena; one son, Edwin; and Edwin's wife, Hortense.

made headlines the world over and basically brought an end to the New England vampire. Mercy Brown would be the last known case to be documented. Here is the rest of the story:

Within a few years George T. Brown of Exeter has been bereft of a wife and two daughters by that dreaded disease consumption. His wife, Mary E., daughter of Pardon M. Arnold, was first stricken down eight years ago, leaving her husband with six children, one son and five daughters.

Within two years from the mother's death the eldest daughter, Olive B., died of the same disease, leaving the other members of the family apparently in good health. In a few years the son, Edwin A., who has been employed as clerk by G. T. Cranston and by Taylor & Davis of Lafayette, was taken ill, and by the advice of friends went to Colorado Springs about 18 months ago. During his absence the past winter another daughter, Mercy Lena, who appeared in good health at his departure, passed away after a few months of suffering. Three weeks ago Edwin A., finding his health so rapidly failing, came back to Rhode Island and is now critically ill at the residence of Willet Himes, his father-in-law.

During the few weeks past Mr. Brown has been besieged on all sides by a number of people, who expressed implicit faith in the old theory that by some unexplained and unreasonable way in some part of the deceased relative's body live flesh and blood might be found, which is supposed to feed upon the living who are in feeble health. Mr. Brown, having no confidence in the old-time theory, and also getting no encouragement from the medical fraternity, did not yield to their importunities until Thursday afternoon, when an investigation was held under the direction of Harold Metcalf, M.D., of Wickford. The bodies of the wife and two daughters, who were buried in the Exeter Cemetery, were exhumed and an examination made, finding nothing but skeletons of the bodies of the wife and the eldest daughter. After examination of the body of M. Lena, who was buried nine weeks ago, Dr. Metcalf reports the body in a state of natural decomposition, with nothing exceptional existing. When the doctor removed the heart and the liver from the body a quantity of blood dripped therefrom, but this he said was just what might be expected from a similar examination of almost any person after the same length of time from decease. The heart and liver were cremated by the attendants. Mr. Brown has the sympathy of the community.

It seems that the newspaper was not completely done with the event and felt a need to update and clarify its previous story. On March 21, 1892, the

Journal printed a follow-up article, delving further into the vampire theory and the accounts that led up to the Exeter exhumation. I acquired a copy of the two articles, the above account and the follow-up story below, in an attempt to understand what the writers were thinking while penning the actual accounts that transpired as told at the time of their experience. With kind permission from the *Providence Journal*, supplemented by research in Michael Bell's *Food for the Dead* and Christopher Rondina's *Vampire Hunter's Guide to New England*, the article is reprinted here in its entirety as it appeared in 1892:

The vampire theory-that search for the spectral ghoul in the Exeter graves. Not a Rhode Island tradition, but settled here.
It originated in Europe. Cremation of the heart of the sister for the consumptive brother to eat the ashes.

"Ugh!" says the person of refinement. "Horrible!" ejaculates even the reader of the horrible daily papers. But those who believe in it express themselves thus; "It may be true," "You may find one there," "I always heard it was so," and "My father and grandfather always said so." From traditions of the vampire, it is, on the whole, pleasant to be free, but how singular that this old belief of the Hindoos and Danubian peoples should survive in Rhode Island! Had such a superstition been acted upon in White Russia or lower Hungary, Rhode Islanders would have read it as fiction, or a strange, wild falsehood, but this exhumation in the South County, in the town of Exeter, with the names of the persons authorizing it known in the county, and with a modern physician assisting, is a fact divested of mystery or fictional description. People who believed in the theory went to the Medical Examiner of the District, and he had the bodies exhumed, and examined them. It is probable that the theory was never practiced in this state under a better light of publicity, discussion and criticism.

Dr. Harold Metcalf, the Medical Examiner of the District, who examined the bodies, is a young and intelligent graduate of Bellevue. He is a Providence boy and, after his graduation, located in the city, but three or four years ago removed to Wickford. He is not one to believe in the vampire superstition. He spent too long a time on the hospital aid wagons which are sent into the New York streets from Bellevue, to believe in anything relating to the human body which cannot be proven by the ordinary methods of medical science. He was called into the affair because he was the best physician nearest to Exeter, and examined the bodies because he was paid to do it. He in fact discouraged the suggestion, and affirmed that the result would be futile. He made his examination as yesterday's Journal *stated,*

without exceptional results, according to his own belief, but found in one of the bodies, to the satisfaction of many of the people down there, a sign which they regarded as the proof of their theory. When he removed the heart and liver from the body, a quantity of blood dripped therefrom. "The vampire," the attendants of the doctor said - and then, conforming to the theory of the necessity of destroying the vampire, burned the heart and liver. The people who urged the husband and father to exhume the bodies believe the vampire was found, and if the young man for whose sake the experiment was made recovers from his illness, they will, it is presumed, by reason of their acceptance of the truth of the tradition, consider the recovery due to the destruction of the spectral agent of his apparently fatal illness.

The vampire is described in the Century Dictionary *as follows: "A kind of spectral being or ghost still possessing a human body which, according to a superstition existing among the Slavic and other races of the lower Danube, leaves the grave during the night, and maintains a semblance of life by sucking the warm blood of men and women while they are asleep. Dead wizards, werewolves, heretics and other outcasts become vampires— and anyone killed by a vampire. On the discovery of a vampire's grave, the body, which it is supposed, will be found fresh and ruddy, must be disinterred, thrust through with a whitethorn stake and burned, in order to render it harmless. In the Encyclopedia Britannica and other books, a similar description of the theory occurs. They all recount that the tradition comes from Europe and did not originate among the Indians. Its earliest existence is said to have been in Southwestern Russia, Servia, Poland and Bohemia. It is claimed also that it has prevailed to a certain extent in India, though the authorities at hand do not refer to this. The sole authority for the origin and prevalence of the idea outside of the Slavic peoples rests in stories written by two or three noted Frenchmen and a number of less prominent English writers. From 1730 to 1735 the tradition took on renewed life, and starting in Hungary, spread all over Europe, and to America. At this time, two of the principal books, written upon the subject were published;* De Masticatione Mortuum in Tumulis, and Camlet's (Calmet's) Dissertation on the Vampires of Hungary *translated into English in 1750. The belief and the tradition was now marked by varying impressions of the form that the vampire took, and quite as variant opinions of the means necessary for the crushing of the power of the being or essence.*

In all forms of the tradition, the vampire left its abode, and wrought its object, at night. When the full moon shone and the sky was cloudless, its opportunity was supposed to be most favorable. It left the body of the dead

at the back of the neck, and appeared as a frog, toad, spider, venomous fly, from that moment until it returned to the grave and its corpse home. Its active moments when wandering about were spent in sucking the blood of the living, and this was invariably the blood of some relation or friend of the dead. From this feeding, the body of the dead became fresh and rosy. Another form of the tradition, but with far less acceptance, was that the soul of the living man or woman left the body in his sleep in the shape of a straw or fluff down. It was wafted to the victim on the night breezes and returned to the living without a warning of the visit, the victim being left pale and wan, and the vampire-man being freshened and invigorated. Grantier has diverted the sense of the tradition to the plot of a powerful short story. For the eradication of the curse, the old method was always the digging up the body of the dead and the driving of a stake through the heart, the cutting off of the beard, the tearing out and burning of the heart, or the pouring of boiling water and vinegar into the grave.

How the tradition got to Rhode Island and planted itself firmly here, cannot be said. It was in existence in Connecticut and Maine 50 and 100 years ago, and the people of the South County say they got it from their ancestors, as far back in some cases as the beginning of the 18^{th} century. The idea seems never to have been accepted in the northern part of the state, but every five or ten years it has cropped out in Coventry, West Greenwich, Exeter, Hopkinton, Richmond and the neighboring towns. In the case that has called out this reference to the subject, the principle persons interested were a farmer, George T. Brown, and his son Edwin A. Brown, a young man living near Shrub Hill, about two miles east of Pine Hill, which is the center of Exeter. The family had within four years suffered the loss of the wife and mother, four years ago; a daughter, Olive B., three years later, and Mercy Lena, another daughter, during the past winter. The son, Edwin A. Brown, was taken with the same disease, a harsh type of consumption, two years ago. His sister Lena became ill while he was in Colorado, where he had gone to improve his condition. Three weeks since, Edwin, finding his health fading, even in that favorite resort for consumptives, returned to Exeter.

The local correspondent of the Journal *tells the story of the call for Dr. Metcalf to hunt out the vampire, and of what occurred when the graves were searched as follows:*

It seems that Dr. Metcalf attended Mercy Lena Brown during her last illness, and that a short time prior to her death he informed her father that further medical aid was useless, as the daughter, a girl of 18 or 19, was in the last stages of consumption. The doctor had heard nothing further from

the family until about a week ago when a man called on him and stated that Edwin A. Brown, the son, was in a dying condition from the same disease, and that several friends and neighbors fully believed the only way in which his life could be saved was to have the bodies of the mother and two daughters exhumed in order to ascertain if the heart in any of the bodies still contained blood, as these friends were fully convinced that if such were the case the dead body was living on the living tissue and blood of Edwin. The doctor sent the young man back, telling him the belief was absurd. Last Wednesday the man returned and told the doctor that Mr. Brown, the father, though not believing in the superstition himself, desired him to come up to satisfy the neighbors and make an autopsy of the bodies.

On Wednesday morning therefore, the doctor went as desired to what is known as Shrub Hill Cemetery, in Exeter, and found four men who had unearthed the remains of Mrs. Brown, who had been interred four years. Some of the muscles and flesh still existed in a mummified state, but there were no signs of blood in the heart. The body of the first daughter, Olive, was then taken out of the grave, but only a skeleton with a thick growth of hair remained.

Finally, the body of Lena, the second daughter, was removed from the tomb, where it had been placed till spring. The body was in a fairly well preserved state. It had been buried two months. The heart and liver were removed and in cutting open the heart, clotted and decomposed blood was found, which was what might be expected at that stage of decomposition. The liver showed no blood, though it was in a well-preserved state. These two organs were removed, and a fire being kindled in the cemetery, they were reduced to ashes, and the attendants seemed satisfied. The lungs showed diffuse tuberculous germs.

The old superstition of the natives of Exeter, and also believed in other farming communities, is either the vestige of the black art, or, as the people living here say, is a tradition of the Indians. And the belief is that, so long as the heart contains blood, so long will any of the immediate family who are suffering from consumption continue to grow worse; but, if the heart is burned, that the patient will get better. And to make the cure certain the ashes of the heart and liver should be eaten by the person afflicted. In this case the doctor does not know if this latter remedy was resorted to or not, and he only knows from hearsay how ill the son Edwin is, "Never having been called to attend him."

All mention of "the vampire" is omitted from this account of the exhuming, but this signifies nothing. The correspondent simply failed to get

to the bottom of the superstition. *The files of the Journal where reference is made in them to the practice of the tradition in Rhode Island, without exception speak of the search of the graves in such cases as attempts to discover the vampire. The last illustration of the practice was six or seven years ago in the same county, and it was then so described. Previous accounts of the digging up of bodies for the same purpose are also inspired by the vampire theory. Otherwise the analogy between this case and those which occurred in Europe in the 18th century is perfect, except in the confinement of the theory to a special disease, and the terrible suggestion that the patient must take the ashes of the vampire internally to be cured. These ideas are not, so far as can be learned, based on any form of European tradition. The books and authorities of Europe do not connect the theory with consumption, nor, in its legend, turn upon that application, with the victims eating the vampire. This presentation of the theory must be of American or Rhode Island origin, and most likely it can be claimed as the exclusive possession of Rhode Island's country people. It is horrible to contemplate, and the local correspondent can hardly be blamed for attributing it to the Indians. It seems very odd that the South County people alone should ever had re-gendered and accepted such fancies.*

A little may be added to the story upon the medical side. The family was not hereditarily consumptive, but consumption is, of course, liable to start from causes besides family predisposition. The physicians, on the other hand, are unwilling to affirm that it is invariably contagious, but assert that it abounds from causes closely allied to the operation of a contagion. For example, a person remaining in the room with a consumptive, attending upon such a sufferer during his or her illness, or living subsequent to the death of a consumptive under the same hygienic conditions, is generally considered to be in danger of the disease. Thus in the case of this family, even providing the children did not take the disease from a hereditary susceptibility to it, they were subjected to its influence, for they all lived in the farm house with their mother when she died, the daughter nursed her, and by the time the son took it, he had been under its fatal power according to intensified, if not multiplied circumstances of danger. In regard to the blood and the condition of the heart of the daughter Lena, who had been dead but two months, Dr. Metcalf's statement that the blood and the unexhausted molecular composition of the heart were not signs of a state of affairs at all unusual, will be borne out by any good physician, for it is well known that the heart, the fountain of the blood, usually retains till the final time of decomposition the semblances of its function.

Dr. Metcalf made his autopsies in the cemetery before the men who had been employed in digging up the bodies, and they, according to the doctor's story as told by the correspondent, appeared satisfied that the cause of Edwin Brown's illness, or the remedy for his cure, had been found. They had believed a vampire lay in one of the bodies; they had searched for it; they had found it. If the sick man is now cured by the adoption of these means, which includes his absorption of the cremated heart of his sister, it is assumed that, believing as these people do, they will assign the cause of returning health to the remedy they adopted. What therefore is one to say? It is a temptation to treat the whole affair as something ridiculous, but if it be so regarded, the facts in the case likewise, suggest the most sorrowful and hideous of pictures. To write and interpret the facts in their unvarnished form, here in this city, but 25 miles from the scene, is a task requiring imaginativeness almost sufficient to cover an inhuman rite of the Africans of the upper Congo, or to compass one of Rider Haggard's most thrilling chapters.

In the mentioning of the books by Ranft and Calmet, the word "mortuum" should probably be mortuorum, and in the copy of the article it appears that Calmet's is spelled "Camlet's." Also, in Grantier's section for eradication of the curse, the article does state "the cutting off of the beard" as opposed to what may have been meant: "the cutting off of the head."

The writer seems to want to reiterate the idea of vampirism in the previous work, trying to cite previous articles and writings as his platform. He also mentions that the tie between vampires and consumption is of American origin. Perhaps he never read Voltaire's description of a vampire. The writer also mentions that Mrs. Brown had died only four years earlier when in truth she had been buried a little over eight years at the time of the exhumations. Mary Olive died six months after her mother, not three years later like the article states.

Mercy was held in the Keep at the cemetery due to the fact that, being in the throes of winter, the ground was frozen solid and a proper grave could not be dug until the spring thaw. The Keep—or crypt, as some call it—is a small building in a cemetery where the bodies of the deceased who die in the winter can be held until spring. Some families used to keep their loved ones in the cellar of the home or, as in the case of the Hale Homestead, home of Nathaniel Hale, in the attic. Both places were cold enough, if not actually freezing, to keep the deceased well preserved until they could be buried. Most rural families had their own private graveyards somewhere on their property. Because of this practice, Rhode Island has the most cemeteries in

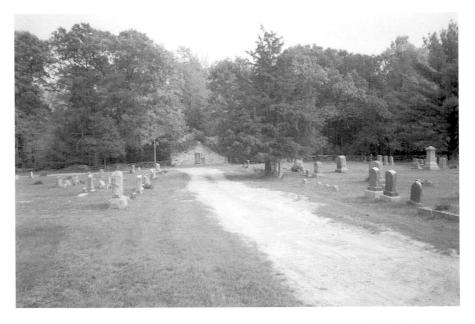

Looking at the Keep from the Brown burial plot. This is where Mercy was being held pending proper burial following the spring thaw.

the United States, with about thirty-three hundred and counting. Many of these had their personal little Keeps as well.

Another use for these small crypts was to store the body for several days in case the person suddenly woke up. There were bells attached to them, and food was placed within. If the person woke up during the several-day period, he or she could ring the bell and be let out. This is supposedly where the term "wake" comes from. Many times, a person was in a coma or appeared to have died but would wake up suddenly. The idea of holding them in the Keep served well in many cases where contagious diseases would not allow the person to be laid out in the house.

In response to the *Journal* articles, there was a commentary written to the editor of the now-defunct *Pawtuxet Valley Gleaner*, a weekly paper that covered the Phenix and Kent County areas of Rhode Island from 1876 to 1906:

Pawtuxet Valley Gleaner
Letter to the Editor
March 25, 1892
Mr. Editor, as considerable notoriety has resulted from the exhuming of three bodies in Exeter cemetery on the 17th inst., I will give the main facts

as I have received them for the benefit of such of your readers as "have not taken the papers" containing the same. To begin, we will say that our neighbor, a good and respectable citizen, George T. Brown, has been bereft of his wife and two grown-up daughters by consumption, the wife and mother about eight years ago, and the eldest daughter, Olive, two years or so later, while the other daughter, Mercy Lena, died about two months since, after nearly one year's illness from the same dread disease, and about two years ago Mr. Brown's only son Edwin A. , a young married man of good habits, began to give evidence of lung trouble, which increased, until in hopes of checking and curing the same, he was induced to visit the famous Colorado Springs, where his wife followed him later on and though for a time he seemed to improve, it soon became evident that there was no real benefit derived, and this coupled with a strong desire on the part of both husband and wife to see their Rhode Island friends decided them to return east after an absence of about 18 months and are staying with Mrs. Brown's parents, Mr. and Mrs. Willet Himes. We are sorry to say that Eddie's health is not encouraging at this time. And now comes in the queer part, viz: The revival of a pagan or other superstitions regarding the feeling of the dead upon a living relative where consumption was the cause of death and so bringing the living person soon into a similar condition, etc, and to avoid this result, according to the same high authority, the "vampire" in question which is said to inhabit the heart of a dead consumptive while any blood remains in that organ, must be cremated and the ashes carefully preserved and administered in some form to the living victim, when a speedy cure may (un)reasonably be expected. I will here say that the husband and father of the deceased ones has, from the first, disclaimed any faith at all in the vampire theory but being urged, he allowed others if not wiser, counsel to prevail, and on the 17th inst., as before stated the three bodies alluded to were exhumed and then examined by Doctor Metcalf of Wickford, (under protest, as it were being an unbeliever). The two bodies longest buried were found decayed and bloodless, while the last one who has been only about two months buried showed some blood in the heart as a matter of course, and as the doctor expected but to carry out what was a forgone conclusion the heart and lungs of the last named (M. Lena) were then and there duly cremated, but deponent saith not how the ashes were disposed of. Not many persons were present, Mr. Brown being among the absent ones. While we do not blame any one for there proceedings as they were intended without doubt to relive the anxiety of the living, still, it seems incredible that any one can attach the least importance to the subject, being so entirely incompatible with

reason and conflicts also with scripture, which requires us "to give a reason for the hope that is in us," or the why and wherefore which certainly cannot be done as applied to the foregoing.

In some of the stories I have read, the writer tells of how Mr. Brown became convinced that something had to be done to stop his family from falling prey to consumption, but as we know, he knew that it was all superstition and held no true weight in the reality of what consumption really was. Just about twenty miles away, in the city of Providence, they were treating what was now being called tuberculosis.

Mercy Brown's case would resound worldwide, bringing the New England vampire exhumations to an end, but not before making history in writings by Bram Stoker and H.P. Lovecraft. Upon reading Lovecraft's masterpiece,

A rare view of the inside of the Keep at Chestnut Hill Cemetery. The entrance has been bricked up and the door welded shut. *Photo Courtesy of Christopher Martin of www. quahog.org.*

Another view of the inside of the Keep at Chestnut Hill Cemetery. *Photo Courtesy of Christopher Martin of www.quahog.org.*

The Shunned House, it is no surprise that the mention of the 1892 exhumation would be, at times, a focal point in the story. Lovecraft relished in New England folklore and legends, incorporating many of them into his stories. It is interesting how he repeatedly speaks of the Exeter "rustics," a word he seemed quite fond of when referring to the rural folk of the region. He even names one of the characters in his story Mercy. Lovecraft draws heavily on the incident while weaving his own brilliant imagination into a fantastic tapestry of bizarre and enticing literature worthy of any parchment.

When Mr. Stoker died, his articles were sold off. Among them was material he used to write his novel *Dracula*. Found among the material were newspaper clippings of the Mercy Brown case. This could be why he used the town of Exeter in his novel. I did a few lectures on New England vampires for my old high school in Smithfield, Rhode Island, because the English literature class was studying *Dracula* at the time. The teacher, Mrs. Pereira, is a huge vampire fan, and it was a lot of fun speaking to the three classes within a two-day period. In fact, some of the teachers actually canceled their classes to hear about the New England vampires. They were amazed at the fact that Stoker had possession of such articles and had actually used portions of the Rhode Island vampire to create his immortal classic.

An interesting endnote in regard to Mercy Brown's case comes by way of the cemetery records for Exeter Historical Cemetery #22. In the grave descriptions, it clearly states in a special note under her name, "This unfortunate girl, who probably died of tuberculosis, was accused of being a vampire. She was dug up and her heart taken out and burned."

TUBERCULOSIS IN THE TWENTIETH CENTURY

E ven during the exhumation of Mercy and her sister and mother, tuberculosis was being effectively treated. During the eighteenth and nineteenth centuries, as many as one out of three people died from the disease, especially in remote rural areas where, as Dr. Bowditch concluded, the climate was damp and ripe for the spread of the horrible infection. This, however, would change with the twentieth-century discoveries that medical science developed in regard to the treatment of tuberculosis.

By 1895, Wilhelm Konrad Von Roentgen had discovered a radiation treatment that could monitor a patient's progress, either positive or negative. This was another major step in the fight against the dreaded disease. The National Tuberculosis Association was formed in 1904 to promote more awareness, encourage prevention and work toward a cure for TB. The society later changed its name to the American Lung Association. The first somewhat successful vaccine for TB was the BCG vaccine (Bacillus Calmette-Guerin) named after Albert Calmette and Camille Guerin, who worked on the vaccine. It was first used on humans in 1921.

Sanatoriums and special hospitals were set up to isolate TB patients. These places, despite the ongoing advances in the treatment of TB, still thrived, and the death rate in some cases was devastating. In Burrillville, Rhode Island, there sits the remains of a small village in the middle of the woods that was erected for the purpose of isolating TB patients from the populace. They could live normal lives among themselves and be treated, yet they were far enough from the main population so as to not infect others.

Around World War II, chemotherapy was discovered and became a major victory in the battle against tuberculosis. In 1914, Selman Waksman began research on an antibiotic for tuberculosis. His unending pursuit finally paid off in 1943, when he found that the antibiotic streptomycin not only stopped the spread of the mycobacterium tuberculosis but also caused the existing bacteria to recede from the patient. The remedy was first administered on November 20, 1944, with great success.

Other antibiotics and treatments emerged in seemingly rapid succession. By 1952, isoniazid was on the market as an oral antibiotic for TB. In the 1970s, rifampin was a new drug that made the recovery period of TB patients shorter. These medical wonders drastically reduced the number of TB patients, until the 1980s, when a drug-resistant strain of TB, called multi–drug resistant TB, began to emerge. Although not as widespread as in the past, the disease is still being diagnosed and treated. Most of the serious cases are in developing countries. One must consider that the United States, during the eighteenth and nineteenth centuries, was also a developing country.

Today, millions of people are treated for TB successfully, and the medical field continues to make advances that hopefully will someday turn tuberculosis, like the New England vampire, into a legend of the past.

OTHER STRANGE EXORCISMS
AND INTERESTING LEGENDS

New England has an illustrious history when it comes to witches. It is said that a witch can become a vampire after death. Whether this has been documented in New England, I am not certain, but I do know of some cases where a person was accused of witchcraft and, when death took her mortal frame, was exorcised in a manner much akin to that of the creature of the night. In some cases, the subject is a spirit that has come back looking for life, much like the New England vampire, but in a different method. The main difference between what we call a witch and what we call a vampire is that witches might do their evil bidding out of revenge, and vampires are just trying to survive.

A vampire was often discovered and destroyed after the body was dead, while witches were still alive when done away with. Our modern take on vampires and witches casts them as having irresistible powers, as well as charming looks. Old New England legends make witches mostly hags—old and wicked with ghastly features—yet as you will soon read, some of these supposed witches were quite young and comely.

I have found no cases of execution for vampirism in the seventeenth century, or even early eighteenth-century New England. Almost everything bad that happened at this time was blamed on witchcraft. When someone was wasting away or became deathly ill all of a sudden, vampirism was not the culprit. Suddenly, consumption began wreaking havoc, and superstition caused people to dig up family members in search of a spectral creature of the night. Some stories reveal that the villagers were not sure themselves what they were dealing with, witch or vampire. Early Puritan capital laws

made witchcraft punishable by death. The following are some interesting and lesser-known legends of witches that have traces of the vampire legend within them.

In 1647, Alse Young of Connecticut was the first person hanged as a witch in the colonies. One year later, Margaret Jones of Charlestown, Massachusetts, swung from the gallows for allegedly having a pact with the devil. These women were also accused of being able to shape-shift into different creatures, much like a vampire.

Hannah Cranna, Monroe's Famous Witch

Whether Hannah Cranna had authentic powers of the dark side or was just feared for her outgoing brazenness, one thing is certain: she did exist, and her stone sits on a hill in Gregory's Four Corners Burial Ground, overlooking Spring Hill Road on the Monroe/Trumbull border.

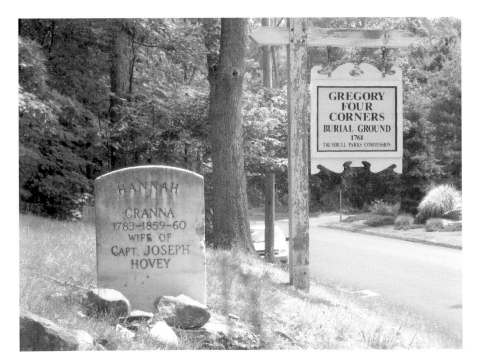

Hannah Cranna Hovey's grave on a rise just above the road in Gregory Four Corners Burial Ground. Legend states that she rises each year to exact revenge upon a passing motorist. *Photo courtesy of Anthony Dunne.*

History tells us that Hannah's real last name was Hovey and that she was married to Captain Joseph Hovey. She was born in 1783 and died in 1859–60. The latter date may have been due to the fact that she died close to the New Year. Cranna was just a nickname given to her. She resided at the summit of Cragley Hill in the Bug Hill–Cutler's Farm section of Monroe. Hannah was quite poor. "Goody" was the term used for humble housewives during the past centuries, but Hanna was more than just an ordinary housewife; she was a witch, or so her neighbors thought.

The villagers were very superstitious, and Hannah took full advantage of this fact. Many of her peers would cede to her wants and needs for fear of having the evil eye cast upon them. Her reputation as a minion of the dark side grew fast and far. It is told that Hannah sat and watched over her realm from a rock seat along Cutler's Farm Road. The devil himself is said to have visited Hannah and left a hoof mark in the rock as a sign of their meeting. Legend has it that her house was even guarded by snakes, a symbol seen in modern vampire and horror movies.

Hannah had a pet rooster called Old Boreas. Many believed the rooster was actually her familiar. Old Boreas would crow at the exact moment of the witching hour each night. The rooster's timing was so uncanny that the townspeople set their watches by it. It was said that those who set their watches by the crow of Old Boreas kept perfect time from that moment on. When Old Boreas died, Hannah buried him in the center of her garden by the light of the midnight moon.

When it came her time to leave her mortal frame, Hannah confided to a neighbor her exact burial proceedings. She was to be buried after sundown, and the coffin had to be carried on foot, not by wagon, to the cemetery. She died the next day, and a terrible snowstorm kept the men from carrying her casket to the cemetery in the knee-deep snow. They loaded her casket on a wagon, despite her wishes, but it kept sliding off. They tried to tie it to a sled and pull it to the burial ground, but the ropes would unknot and the coffin would shake off the sled. Finally, they undertook the slow, arduous task of carrying her casket to the cemetery by foot.

As soon as the last shovel of dirt covered her grave, Hannah's house was said to have mysteriously burned to the ground. According to local urban legend, once a year, Hannah rises from her grave and stands in the middle of the road, where an unwary motorist is forced to swerve in order to miss hitting her. The motorist then crashes into a tombstone—Hannah's—and the town provides her with a new headstone each year. The legend of her rising from the grave to seek out a victim is in vogue with that of a vampire.

Eunice Cole

One particular case I researched was in regard to a woman in Hampton, Hew Hampshire, named Eunice "Goody" Cole.

Eunice Cole was the only woman in New Hampshire to be accused and jailed for witchcraft. Eunice and her husband, William, arrived in the colonies on February 20, 1637, removing from Quincy to New Hampshire in November of that same year. They were among the first settlers of Exeter, New Hampshire, where William's name is penned on the original deed. In 1640, they left Exeter and settled in Hampton. Mrs. Cole was a bit too outspoken for her time. From 1645 to 1656, she appeared before the magistrate several times for her vile tongue. She was arrested for witchcraft in 1657, when she cursed some sailors and their vessel after they found pleasure in poking fun at her. Those who heard her shout out that they would never see home again were convinced that she had made a pact with the devil when the ship was lost during a storm as it passed the Isles of Shoals.

Eunice was released in 1660 to care for her older, now ailing husband but was back in jail within a year for the same charges of witchcraft. William

The memorial stone to Eunice Cole at the Tuck Museum in Hampton, New Hampshire. Her home was somewhere on the property, and it is presumed that she is buried close by. Note that the stone resembles a face with a hat.

died on May 26, 1662, and Eunice was released from jail but had no home to go to; the townsfolk had sold all of her property to care for her husband and pay for her imprisonment. She laid a curse on the village and was sent back to jail. By 1671, old and tired, she was back in Hampton. The people of the town built a crude shack for her to live in and took turns caring for her out of fear that she would curse them again. When she passed away in 1680, the neighbors feared that she would return from the dead to wreak havoc upon them. They dragged her body outside and placed it in a shallow grave. Before they buried her, they drove a stake through her heart to exorcise the demon that they feared resided within. They buried her somewhere near where the Tuck Museum sits today.

Here is an instance where the fear of a witch coming back as a vampire prompted the people of the town to perform an exorcism.

THE LIVING DEAD

In Scituate, Rhode Island, there lived a young man named Charles Mattison, who was to marry a very beautiful local girl. He presented her with a fine engagement ring that became the talk of the village. Unfortunately, the wedding was not to be, as the young woman died abruptly before their nuptials. Being of some wealth, she was buried in a tomb near Middle Pike. In no time at all, the young man found another prospect and sought to purchase another ring, but he found that his funds were not in agreement with his intentions. In desperation, he stole away one night to the tomb of his first love, in hopes of retrieving the ring. After prying open the tomb, he attempted to take the ring, but her finger was swollen and the ring would not budge. He cut the finger off, and in that horrible moment blood spurted from the stub, and the girl jumped up and screamed in agony. The woman had awoken from the dead right before his eyes! Needless to say, the young man fled in terror, never looking back.

The girl actually lived several more years, until finally she once again died and was put back in her tomb. Over time, the story was passed down, and one night the youth of the town decided to check out the tomb. A cow had fallen through the top, as it was built in the side of a grazing hill, and entry was made easy. Mattison heard of this and somehow became obsessed with protecting her place of repose. Every day, he brought fresh flowers, and by night he would guard it from intruders. He even went as far as to tie some boards and old bones together. From a hidden location, he could pull on a

rope, sending the collection into a clamor that would send even the most stout hearted fleeing for safer ground. He remained true to his duty until his death. Here we have a story where the corpse rises from the dead. Of, course if this were really true, it could have just been a premature burial. We have someone watching over her grave in the dead of the night. Even if this story is nothing but legend, it certainly borrows at least a little from the vampire realm.

The Legend of Dolly Cole(s)

There are a few legends surrounding Foster's Dolly Cole. One is that she was a witch who was burned with her home. Another is that she was a witch, and her child was thrown into the river off of the bridge that bears her name. She followed and vanished. Still another is that she was a vampire. There is one more legend claiming that twenty-seven-year-old Dolly Cole was a murder victim, found in the woods near Tucker Hollow Road. There is a bit of fact in all the stories.

The only Dorothy Cole who would fit the bill died in 1860 at the age of ninety-one years, six months and four days. True, there is a bridge named after her, as well as a stream and a hill. That is because her family owned the whole area. Her house did burn down, but years after her death. Sadie Mathewson was murdered in 1899, not 1893, at the age of twenty-four. Perhaps that is the story that has been mixed with legend to create the Dolly Cole we have all been told about. The ghost of a woman has been witnessed standing near the bridge, and it has automatically been attributed to Dolly Cole. I saw the ghost when I was about eleven years old while fishing with my father. It was the first full-blown apparition I had ever seen. It was of a young woman in a white gown with bare feet leaning into the pool to draw water into a wooden bucket. She then floated away down the path. One never forgets his first ghost.

Some have seen a woman near the gun club off Tucker Hollow Road and say that that spirit is Dolly Cole. But that is also where Aunt Lonnie (Lannie) Davis once resided. She swore that after she died she would haunt the area so long as even two boards of her house remained fastened to each other. Maybe someone forgot a board or two when they dismantled the house to appease her restless spirit.

Dolly Cole may not have been a witch, but Foster did have its share of them. For instance, Isiah Brown married Peggy Hurley, or Herlihy, of Ireland. She was renowned for her spells and herbal remedies. Isiah died in 1897 and

The Dolly Cole Bridge at the bottom of Dolly Cole Hill in the Hopkins Mill Historical District. This is where the ghost of a young woman has been witnessed over the years.

is buried at Foster Cemetery #034. Peggy may be buried there, but it is not on record; however, there are a few stones with no inscriptions. Abby and Whaley Brown were called the witches of Jerimoth Hill. The two sisters were feared far and wide for their ability to cast spells and cause items to fly about rooms. They are buried at Foster Cemetery #001 on the Rhode Island–Connecticut border. Abby was born in 1803 and died in 1875, but there is no Whaley Brown mentioned in the records. I researched to see if Whaley was a married name, and it is not. I have visited the cemetery on a few occasions but do not remember seeing a Whaley Brown among the stones. There is a Phila, born in 1805 and died in 1880, and a Pardon Brown, born in 1792 and died in 1869, who would have been about the same age as Abby. Whatever the case, the two sisters were known as witches almost into the twentieth century.

THE YORK WITCH

Mary Nasson of Old York, Maine, was a noted and respected herbalist in the community. It was because of her knowledge in healing with plants that she became known as the "white witch." This moniker has followed her through

the centuries. She was born in 1745 and grew up in the York village. It was there that she married Samuel Nasson and settled down to a life of helping others in the little hamlet. It is said that she also was a skilled exorcist, who rid many houses of demons and afflictions in her time. Her time was rather short, though, as Mary died on August 18, 1774, at the age of twenty-nine.

Her grave stands out among the rest as the only one in the burial yard with a giant slab of granite over the top. If legend is correct, the people of York placed it there to keep the white witch from rising from her tomb. Another plausible theory contends that the slab was placed there to keep the livestock from accidentally digging her up. Farmers, on the condition that their livestock could still graze among the stones, donated land for many of these early burial grounds to the villages. The townsfolk were in charge of the upkeep of their grave sites, and after Mary died, her husband removed to Stanford, thus making it very difficult to tend to his wife's grave on a regular basis. If the stone was placed there to keep the witch from rising, it did not work as well as the townsfolk hoped—at least not in the present era.

According to legend, Mary had no children. Her ghost now roams the area where she is buried. Not only has her spirit been encountered in the burial grounds, but it has been seen across the street as well. Children have

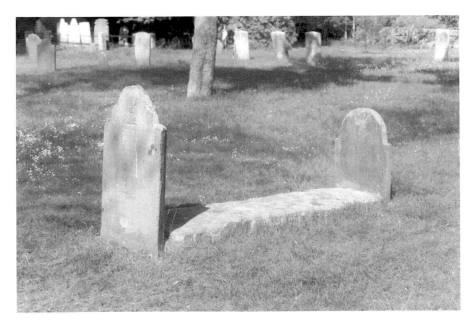

The grave of the "white witch," Mary Nasson, of York, Maine. It is claimed to be the only known burial in New England with a giant granite slab across the top.

spoken of the nice young lady who pushes their swings in the playground across the street. Mothers have even seen the swings moving and have heard the children talking to an unseen entity. If it is Mary, perhaps she has stayed behind to play with the children she always wanted.

DOGTOWN

In the center of Cape Ann there is the village of witches, werewolves and, of course, dogs. Dogtown Common was once home to many of the wealthy folks who sought shelter from coastal pirates and the British. As time went on, the threats receded, and the people of the commons went back to their homes along the shoreline, leaving the ramshackle buildings for the less desirable of the area. These were witches and fortunetellers who would lay curses on those who did not comply with their needs. The early folk acquired dogs for protection from these squatters. As the people died, the dogs became wanderers among the settlement. One witch, Tammy Younger, had fangs that protruded from her mouth. When she died, her spirit was said to occupy the room where her coffin lay until she was buried.

Younger and her partner, Luce George, would give the evil eye to passing villagers who did not yield some of their bounty. It was told that they could freeze an ox team in their tracks with just one look.

The last of the houses came down in the early 1800s, but the witches, werewolves and other creatures that are said to still inhabit Dogtown roam the old trails, looking for the less wary. Dogtown is alive with the people of the past. If the spirits can rise from the tomb, it makes sense that they would remain in a place where magical legends have endured throughout the centuries.

In conclusion, there is no doubt that New England is full of strange facts and folklore in regard to witches, werewolves, demons and vampires. No wonder our ancestors and early settlers took precautions against things they could not see. What did they see back then that we do not today? Perhaps it is sitting right beside us on the bus or subway or walking past us on the street.

BIBLIOGRAPHY

Barker, John Warner. *Connecticut Historical Collection.* 2nd edition. New Haven, CT: Durrie & Peck and J.W. Barker, 1836.

Bellantoni, Nicholas, and David A. Poirier. *In Remembrance: Archeology and Death.* Westport, CT: Bergin and Garvey, 1997.

Bellantoni, Nicholas, and Paul Sledzik. "Bioarcheological and Biocultural Evidence for the New England Vampire." *American Journal of Physical Anthropology* 94 (1994).

Bell, Michael E. *Food for the Dead.* New York: Carroll and Graf, 2001.

Boisvert, Donald J. "Rhode Island Vampires, Eerie Spirits, and Ghostly Apparitions." *Old Rhode Island* 2, no. 9 (October 1992).

Bolte, Mary, and Mary Eastman. *Haunted New England.* Riverside, CT: Chatham Press, 1972.

Bonfani, Leo. *Strange Beliefs, Customs, and Superstitions of New England.* Wakefield, MA: Pride Publications Inc., 1980.

Bowditch, Henry Ingersoll. *Consumption in New England: Or Locality One of Its Chief Causes.* Boston: Ticknor and Fields, 1862.

Cahill, Robert Ellis. *New England Witches and Wizards.* Peabody, MA: Chandler-Smith Publishing House Inc., Collectible Classic No. 1, n.d.

———. *Olde New England's Strange Superstitions.* Salem, MA: Old Saltbox Publishing House, 1990.

———. *Things That Go Bump in the Night.* Peabody, MA: Chandler-Smith Publishing House Inc., 1989.

Carson, Gerald. *Country Stores in Early New England.* N.p.: Old Sturbridge Booklet Series, 1955.

Child, Mrs. *The Frugal Housewife.* Boston: Carter, Hendee & Co. 1833.

Citro, Joseph. *Passing Strange.* Boston, MA: Houghton and Mifflin Company, 1996.

Clauson, James Earl. *These Plantations.* Providence, RI: Roger Williams Press, 1937.

Crawford, Mary Caroline. *Social Life in Old New England.* Boston, MA: Little, Brown, & Company, 1914.

Curran, Robert. *Vampires: A Field Guide to the Creatures That Stalk the Night.* Franklin Lakes, NJ: New Page Books, 2005.

D'Agostino, Thomas. *Abandoned Villages and Ghost Towns of New England.* Atglen, PA: Schiffer Publishing Ltd., 2008.

———. *A Guide to Haunted New England: Tales from Mount Washington to the Newport Cliffs.* Charleston, SC: History Press, 2009.

———. *Haunted New Hampshire.* Atglen, PA: Schiffer Publishing Ltd., 2006.

———. *Haunted Rhode Island.* Atglen, PA: Schiffer Publishing Ltd., 2006.

Drake Samuel Adams. *A Book of New England Legends and Folklore in Prose and Poetry.* Boston, MA: Little, Brown & Company, 1910.

Dunne, Anthony. *Things That Go Bump In The Night: Tales of Haunted New England.* Documentary. WGBY, 2009.

Earle, Alice Morse. *Home Life in Colonial Days.* New York: MacMillan Co., 1898.

Feintuch, Burt, and David H. Watters, eds. *Encyclopedia of New England: The Culture and History of an American Region.* New Haven, CT: Yale University Press, 2005.

Gleeson, Alice Collins. *Colonial Rhode Island.* Pawtucket, RI: Automobile Journal Publishing Company, 1926.

Gray, T.M. *Ghosts of Maine.* Atglen, PA: Schiffer Publishing Ltd., 2008.

Jones, Eric. *New Hampshire Curiosities: Quirky Characters, Roadside Oddities, and Other Offbeat Stuff.* Guilford, CT: Globe Pequot Press, 2006.

Kinder, Nancy. *The "Vampires" of Rhode Island: Mysterious New England.* N.p.: Yankee Publishing, 1971. Reprint, Rodale Press, 1993.

Mansfield, David L. "The History of the Town of Dummerston." *Vermont Historical Magazine* (1884).

Marcy, Florence S. *Guide to the History and Historic Sites of Connecticut.* New Haven, CT: Yale University Press, 1937.

Matthews, Margery. *So I've Been Told: Stories of Foster.* Foster, RI: Foster Preservation Society, 1985.

McCain, Diana Ross. *Mysteries and Legends of New England: True Stories of the Unsolved and Unexplained.* Guilford, CT: Globe Pequot Press, 2009.

Norwich Evening Courier. "A Strange Superstition." May 20, 1854.

Observer Publications. October 26, 1972.

Old Colony Memorial and Plymouth County Advertiser. "Superstitions of New England." May 4, 1822.

Revai, Cheri. *Haunted Connecticut.* Mechanicsburg, PA: Stackpole Books, 2006.

Providence Journal. March 19, and 21, 1892.

Rider, Sidney. *Book Notes* 5, nos. 3 & 7, February 4, 1888; March 31, 1888.

Robinson, Charles Turek. *The New England Ghost Files.* North Attleborough, MA: Covered Bridge Press, 1994.

Rondina Christopher. *The Vampire Hunter's Guide to New England.* North Attleborough, MA: Covered Bridge Press, 2000.

Stetson, George. "The Animistic Vampire in New England." *American Anthropologist* (1896). Available online at http://dx.doi.org/10.1525/ahu.2006.31.2.124.

3rd Story Productions, Maria Patsias and Scott Saracen. *Ghost & Vampire Legends of Rhode Island.* Documentary: Rhode Island PBS, 2002.

Townshend, Doris B. *The Lost Village of the Higginbotham's.* New York: Vantage Press, 1991.

Ulrich, Laurel Thatcher. *Goodwives.* New York: Alfred A. Knopf, 1982.

Van Dusen, Albert E. *Connecticut; A Fully Illustrated History of the State from the Seventeenth Century to the Present.* New York: Random House, 1961.

Wilde, Lady. *Irish Cures, Mystic Charms, & Superstitions.* New York: Sterling Publishing Company Inc., 1991.

Wood, Maureen, and Ron Kolek. *The Ghost Chronicles.* Naperville, IL Sourcebooks, Inc., 2009.

WEBSITES

www.ctgravestones.com

www.foodforthedead.com

www.griswold-ct.org

www.hplovecraft.com/writings/fiction.asp

www.joenickell.com

www.masscrossroads.com

www.monroehistoricalsociety.org

www.mountauburn.org

www.nearparanormal.com/tales.html

www.neghostproject.com

www.quahog.org

www.ricemeteries.tripod.com

BIBLIOGRAPHY

www.umdj.edu/globaltb/tbhistory
vampirologist.blogspot.com
www.wikipedia.org

INDEX

A

American Anthropologist 28
"The Animistic Vampire in New
 England" 28

B

Bellantoni, Nicholas, Dr. 23, 40,
 63, 64, 65
Bell, Michael, Dr. 23, 26, 40, 59,
 60, 64, 67, 89, 97, 103, 105,
 114
Bowditch, Henry Ingersoll, Dr. 89,
 90, 92, 125
Brown, Edwin 111, 113, 121
Brown, George T. 111, 113, 121
Brown, Mercy Lena 73, 79, 102,
 108, 111, 113, 119, 121, 122,
 123, 124, 125
Burton, Captain Isaac 49, 50

C

Calmet, Antoine Augustin 20, 28,
 29, 30, 31, 115
Calmette, Albert 125

Clauson, James Earl 25, 26, 56
Cole, Dolly 132
Cole, Eunice 130
Cole, J.R. 105
Cranna, Hannah (Hovey) 128

D

Deveau, Mary 96, 97
Dogtown 135

F

Food for the Dead 26, 60, 67, 89, 105,
 114

G

Guerin, Camille 125

H

History of Tolland County, Connecticut
 105
Hovey, Hannah. *See* Cranna,
 Hannah (Hovey)

J

Johnson, Isaac 39, 40, 41

K

Koch, Robert, Dr. 13, 14, 104

L

Lovecraft, H.P. 122, 123

M

Mansfield, David L. 46, 47, 48
Marten, Benjamin 14
Martin, Christopher 56
Mather, Cotton 15, 26, 34
McCain, Diana Ross 94
McNally, Raymond T., Dr. 27
Metcalf, Harold, Dr. 121

N

Narragansett Times 27
Nasson, Mary 133
Nickell, Joe 50
Norwich Evening Courier 95, 96

O

Old East Cemetery 40
Old Rhode Island 27, 56, 99

P

Pawtuxet Valley Gleaner 120
Pettibone, Judge John S. 49, 50
Providence Journal 111, 114, 120

R

Ray family 94, 95, 96, 97
Rider, Sidney 26, 56, 59, 60, 75
Rose, Phebe 101
Rose, Ruth Ellen 99, 100, 101, 102
Rose, William 99, 100, 103

S

Sledzik, Paul 63, 64
Spaulding, Lieutenant Leonard 45, 46, 47
Staples, Abigail 51, 52, 54
Staples, Stephen 51, 52, 54
Stetson, George 28, 75
Stoker, Bram 122, 123

T

Tillinghast, Sarah 55, 57–59
Tillinghast, Stutley 55, 56, 57, 59

V

Vaughn, Nellie Louise 107, 108, 109
Voltaire 21, 32, 72, 119
Von Roentgen, Wilhelm Konrad 125

W

Waksman, Selman 126

Y

Young, Alse 128

ABOUT THE AUTHOR

Author of *A Guide to Haunted New England* (History Press), Thomas D'Agostino is one of the region's most well-known writers and investigators of the paranormal. His article "Rhode Island: Vampire Capital of America" was published in *FATE magazine* in October 2001. As founders of the Paranormal United Research Society, Tom and his wife, Arlene, have been extensively studying and investigating paranormal accounts for over twenty-eight years. In addition to the History Press title, Tom is author of *Haunted Rhode Island, Haunted New Hampshire, Haunted Massachusetts, Pirate Ghosts and Phantom Ships* and *Abandoned Villages and Ghost Towns of New England* by Schiffer Publishing. Tom also builds musical instruments, rebuilds clocks and antiques and collects rare books on New England legends, haunts and folklore.

Visit us at
www.historypress.net